COLORED PENCIL

for the SERIOUS BEGINNER

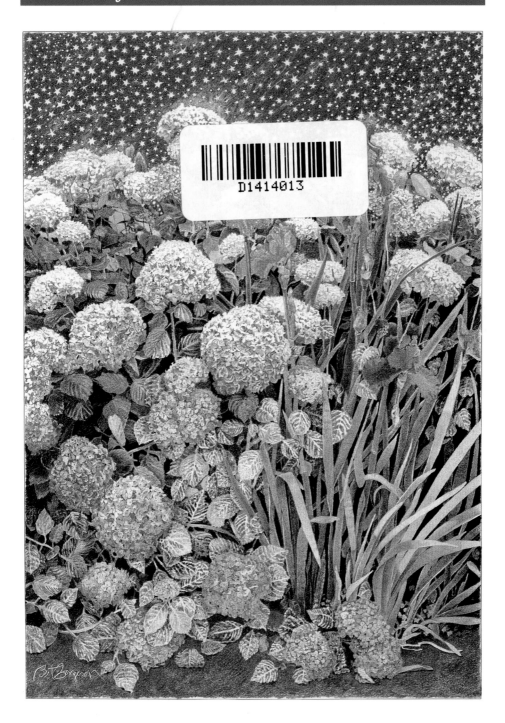

D1414013

COLORED PENCIL

for the SERIOUS BEGINNER

Bet Borgeson

PHOTOGRAPHY BY EDWIN BORGESON

WATSON-GUPTILL PUBLICATIONS/NEW YORK

About the Author

Bet Borgeson is the author of the colored pencil medium's two leading books: *The Colored Pencil* (Watson-Guptill, 1993) and *Basic Colored Pencil Techniques* (North Light, 1997). She began her formal art education at UCLA and, after a move to Oregon, received her fine art degree from Portland State University. Her pioneering contributions to the medium of colored pencil have been widely acknowledged, and her artwork has appeared in many art publications and anthologies in the United States and abroad.

Front cover:
THREE PEONIES IN PATTERNED VASE
Colored pencil on Strathmore Bristol Board,
16 × 13" (41 × 33 cm). Private collection.

Frontispiece:
NIKKOS AND STARDUST
Colored pencil on Rising Museum Board,
19 × 13 1/2" (48 × 34 cm). Collection of the artist.

Title page:
SHADED GOLD
Colored pencil on Rising Museum Board,
12 × 17" (31 × 43 cm). Collection of the artist.

Senior Editor: Candace Raney
Editor: Victoria Craven
Designer: Areta Buk
Production Manager: Ellen Greene
Text set in Adobe Garamond

Copyright © 1998 Bet Borgeson

First published in 1998 in the United States by
Watson-Guptill Publications
a division of BPI Communications, Inc.
1515 Broadway, New York, NY 10036

Library of Congress Cataloging-in-Publication Data

Borgeson, Bet.
 Colored pencil for the serious beginner : basic lessons in
becoming a good artist / Bet Borgeson ; photography by Edwin
Borgeson.
 p. cm.
 Includes index.
 ISBN 0-8230-0761-8
 1. Colored pencil drawing—Technique. I. Title.
 NC892.B685 1998
 741.2'4—dc21 98-28204
 CIP

Printed in Hong Kong

First printing, 1998

1 2 3 4 5 6 7 8 9 / 06 05 04 03 02 01 00 99 98

Contents

Introduction 7

CHAPTER 1
Materials 9

The Pencils • Drawing Surfaces • Sharpeners and Other Basic Tools • Setting Up a Workspace

CHAPTER 2
Fundamentals 17

Drawing • Color and Drawing • Mixing Color with Colored Pencil • A Colorist Approach • Creating Illusions of Form, Volume, and Space • Composition • The Primal Nature of Edges

CHAPTER 3
Getting Started 41

Ideas and Inspiration • Working from Life and from Photography • Building Your Own Techniques • Demonstration: Color Lifting Techniques • Demonstration: Impressed Line Technique • A Working Procedure • Appraising Work in Progress • Knowing When You're Finished

CHAPTER 4
Still Life and Floral 61

Selecting and Setting Up a Still Life • Lighting Your Still Life • Integrating Subject and Background • Demonstration: A Still Life • The Floral Still Life • Demonstration: A Floral Still Life

CHAPTER 5
Landscape 81

The Rooms of Landscape • Working from Location to Studio • Finding Your Setting and Center of Interest • Using Color to Suggest Space • The Eloquence of Understatement • The Naturalistic Landscape • Demonstration: A Natural Landscape • The Imaginary Landscape • Demonstration: A Fantasy Night Landscape

CHAPTER 6
Afterword: Art and Independence 117

Becoming a Lifelong Artist • Blending Art with Livelihood • Exhibiting and Selling Your Art • The Long View: Laddering Your Goals

Index 128

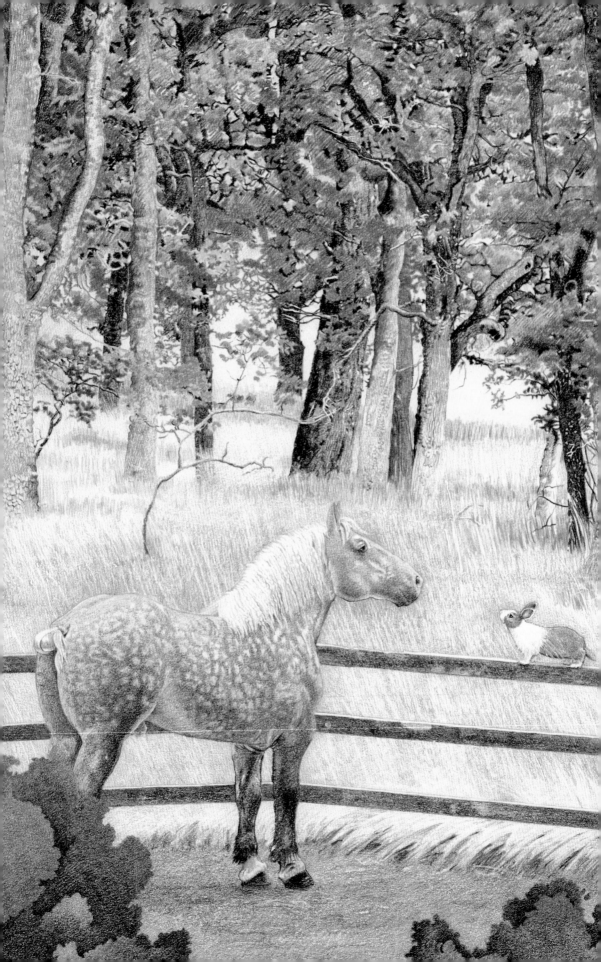

Introduction

As a serious beginner in art, or as a newly serious artist, you are now on a road that will likely lead you back to yourself. Art lies within us, not somewhere else. I hope this book will become a useful and frequent guide, and that you find in it much more than just technique. This book emphasizes information and philosophy about those large areas of art principles and tenets that come before technique and also after it—where artwork's true decisions are made and directions chosen.

After a brief look at tools and drawing materials, we'll begin with the fundamentals for creating illusions of form and space, and how special properties of color can reinforce this. We'll also talk about composition, the ways in which it can be approached, and how you can work toward improving your sense of it.

We'll build a working procedure that begins with how ideas are generated, encompasses various basic colored pencil techniques, and then goes on to outline methods for appraising your work—while in progress and near its completion. With this and more information securely in place, we'll move on to the drawing of still life, floral, and landscape, with explanations of minimalistic, naturalistic, and imaginary approaches. In the step-by-step demonstrations we'll discuss the decision making and problem solving aspects. This because making art is not a pat or guaranteed thing, but is rather a fluid and dynamic process—a visual record of choices made.

In this book, because it is aimed at the serious beginner, I have also included an afterword, with some specific ways of blending a life in art with the concerns of earning a livelihood.

THE PERCHERON AND
THE RABBIT (DETAIL)
Colored Pencil on Rising Museum Board,
18¹/₂ × 24" (47 × 61 cm). Collection of
Washington State Arts Commission,
Art in Public Places Program in partnership
with Manitou Elementary School.

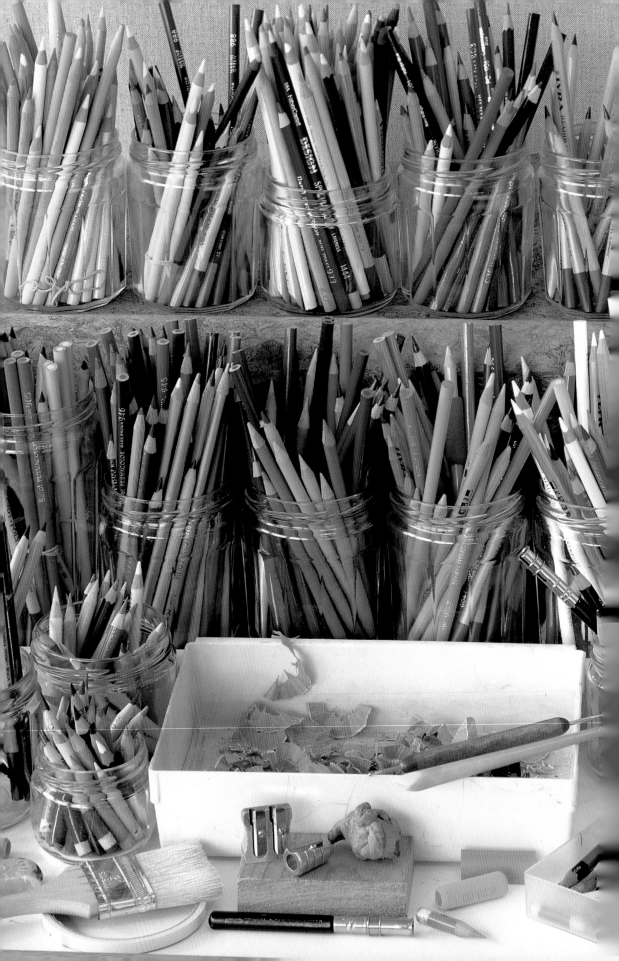

Materials

The tools in any art medium contain characteristics and idiosyncrasies of their own. They have a weight and a feel about them. As any regular user of tools knows, the right tool can seem like an almost magical extension of mind and hand. The wrong tool can seem antagonistic—even angry. When you begin to work at art, you enter into a partnership with all of your materials. It is important that they be friendly to your efforts, and that as you use them they allow your mind to be open, active, and unencumbered by any resistance from them.

In Chapter 1 the materials of the colored pencil medium are described, as are some of my opinions about them. An example of this is discussion about the merits of a handheld sharpener versus an electric sharpener. For even the seemingly simple task of sharpening pencils (no small thing with this medium) can be frustrating and time wasting if the tool chosen is the wrong one for you. So it is with paper and even the nature of the pencils themselves. This first chapter is offered in the hope of helping sort out such issues, and of guiding you in the selection of your materials. It also includes a frank discussion of workspaces—of how simple a space is truly needed, and what kind of studio lighting works best when working with colored pencils.

It is important to me to have all my tools visible and within easy reach of my drawing board. Jars of various sizes are perfect for organizing pencils by color, length, and sometimes brands. I also have a revolving caddy on a shelf under my taboret's tabletop for materials that are less used.

The Pencils

Colored pencils now come in a multitude of brands—domestic and foreign—and vary widely in such characteristics as softness, strength of color, and manufacturer's quality control. Generally, however, all colored pencils can be divided into two basic categories: water-soluble and non-water-soluble.

Non-water-soluble pencils are wax- or oil-based, and are considered the more lightfast, or resistant to fading, of the two. Water-soluble pencils appear more like watercolor when used with water and a brush. In actual use, however, both kinds of pencil are easily compatible with each other. And most all brands of true colored pencils can be successfully blended and used together.

COLORED PENCILS ARE TRANSPARENT

A certain confusion sometimes occurs because art supply stores often display pastel pencils with or near colored pencils. They certainly look much alike. But in use their differences are enormous.

Colored pencils are semi-opaque—what is loosely called transparent. It is this quality (exactly the opposite of a pastel pencil) that makes possible the everchanging and nuance-filled layering of colors, for which the colored pencil medium is best known.

SELECTING A PALETTE

At the present time, the Prismacolor brand of colored pencils is the one most frequently stocked by art supply stores. But other brands too are rising in availability and popularity. Experienced artists often have a mix of brands, although one brand may dominate.

Avoid buying complete sets with pencils you may never use. Buy from "open stock"—the racks of individual pencils.

Build your palette by choosing colors from the hue families arranged around a color wheel, such as red, red-orange, orange, and so on. Add white, black, and some earth colors such as yellow-ochre, sepia, and umber. Do include some colors that have a special appeal for you. (Before making your selection, look over the color section in Chapter 2.) Colored pencil palettes are larger and more diverse than those of traditional mediums because the pencil color comes to us already mixed, although we must continue to adjust these mixtures.

As you become more experienced, and particularly if you are selling your work, you will need to become knowledgeable about color lightfastness. A few pencil companies provide such ratings. At least two brands (Faber-Castell Polychromos and Bruynzeel Fullcolor pencils) carry a lightfastness rating on the pencils themselves. For other brands such information can often be obtained by writing to the manufacturer.

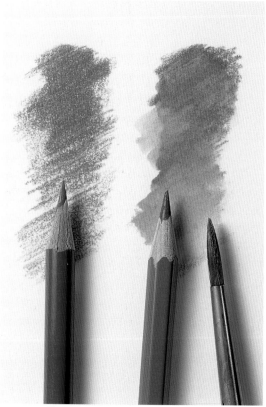

The blue-green sample at left was applied with a wax-based Prismacolor pencil which has a characteristic granular appearance on a medium grain paper. The sample at right was made with a Bruynzeel Design Aquarel pencil—then manipulated with brush and water. Prismacolor pencils are mostly used dry, but can be manipulated with a brush and turpentine.

Drawing Surfaces

There is an important relationship between a colored pencil's point and the surface on which it is used. Because these pencils are usually used tonally, with solid areas of color rather than lines of color, surface texture becomes extremely important.

While colored pencils can be applied to a variety of surfaces—film, unglazed clay, and canvas to name some—white paper remains the most popular. There are many qualities of white paper, and the task of sorting them out can seem daunting. But it need not be. In fact, because so many papers do work well, it may be more helpful to begin by considering what probably won't work. As a start, follow these directions:

1. Avoid common wood pulp paper, such as newsprint and other limp papers. Fragile paper will not hold up under repeated layering or to some of the techniques that will abrade and distress a surface.

2. Avoid soft papers that respond to a pencil's stroke in a mushy way. You will never get a crisp line or edge on this kind of surface.

3. Avoid rough or stylized surface textures. An understated, irregular surface (medium-grained or medium-toothed) will usually prove most desirable.

It is worth noting that a smooth hot-pressed or plate-finished paper can yield a delicate and fine silky line. But it does this at a cost of reduced color intensity. This may or may not be acceptable, depending on your personal style.

When you begin to experiment with colored pencils, try many papers. It is next to impossible to tell by mere touch whether or not a paper is right for you. Nor will even the best-intentioned advice from other artists necessarily be relevant to you. Only by drawing on a paper can you discover its nature and usefulness for yourself.

However, it is not necessary to begin experimenting with the most expensive 100-percent rag papers. Postpone this until you truly need and want such archival quality. In this regard, by the way, a paper described as being buffered or acid-free will probably not stay so for too long. When you need 100-percent rag quality, stay with 100-percent rag.

COLORED PAPERS

Some colored papers, when used with colored pencils, will dramatically increase color luminosity. The papers that best generate this effect are usually of low intensity and of middle to dark value. While this combination of colored pencil and paper can be exciting, readymade colored papers often have too much surface texture for good color laydown. Worse yet, most of them fade. An alternate route is to make your own colored surface with a watercolor or liquid acrylic wash on a good white paper or board. This can be done for an entire surface, or for limited areas as needed.

OTHER DRAWING SURFACES

Any surface having a slight grain can be successfully used with colored pencils. Thus far, such exotic surfaces as pastel cloth, unglazed clay, wood, canvas, or others have played a minor role in this medium. A few of these may be very worth experimenting with, particularly if you are seeking a unique look.

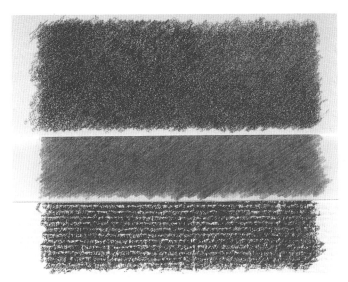

The top sample is on a medium-grain paper and represents the most familiar appearance of colored pencil work. On the smooth middle paper sample, color appears finely grained but less intense. The bottom paper has a texture that is too insistent for most colored pencil use.

Sharpeners and Other Basic Tools

Unlike the graphite pencils used for writing and drawing, colored pencils require a constant monitoring and adjusting of their lead sharpness. For this reason it is essential that your sharpening method be comfortable, unobtrusive, close at hand, and smoothly integrated into your whole drawing process.

While the most common method of sharpening colored pencils is with some form of electric sharpener, this may not be the best method for you. My own way of working is to start a new pencil's point with an electric sharpener then switch to the small handheld aluminum or "brassy" sharpener for ongoing sharpening. Another useful feature of an electric sharpener is its ability, when a lead is breaking frequently, to bulldoze right through multiple lead fractures.

But they also have certain downsides. One is that they can produce a clean, long-shafted appearance of sharpness, while still leaving a lead's tip too blunt, which will generate excessive texture in solid areas of color. Another complaint is that they can be merciless in the "eating" of pencils.

When you shop for a handheld sharpener, try to find one with two openings—oversized and regular—and with replaceable blades. Use the regular opening for most of your sharpening, but move to the oversized opening if a pencil proves itself a "breaker." The larger opening produces a shorter shaft by taking off less wood—a gentler treatment for a finicky pencil. The reason for replaceable blades is that a dull blade will slow sharpening. Make sure your art supply store stocks blades for the sharpener you buy.

Tip

Be fussy. When you purchase individual pencils, make sure their leads are well-centered, and that both halves of wood look well-matched. This will gain you much trouble-free sharpening, with few broken leads.

COLOR LIFTING TOOLS

The uses for most art materials are predictable and straightforward—but not in this category. With colored pencils, the lifting and manipulation of color is done with frisket film, ordinary masking tape, and various sizes and shapes of burnishers—all used in unlikely and ingenious ways. Specific materials and methods for this are covered in Chapter 3.

ERASERS

A white plastic eraser is generally used for cleaning *white* areas within a drawing, or in its margins. A kneaded eraser is used to lighten (by pressing and lifting) *colored* areas.

A handheld portable electric eraser can also be used successfully, and some artists have become quite devoted to them for stylistic reasons. But for most of us this is not really considered a basic tool, but rather one that can be added later.

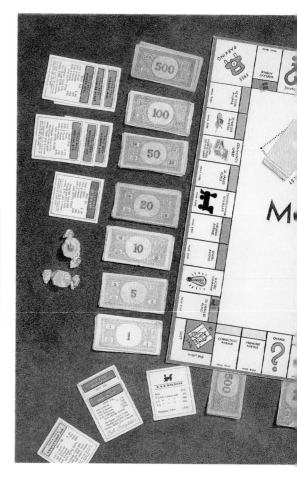

GAME TABLEAU (DIPTYCH)
Colored pencil on Strathmore Bristol Board,
27 × 22" (69 × 56 cm) (each panel). Private collection.

For a heavily textured appearance—such as the carpeting surrounding the gameboard—pencil points were allowed to become flat or dull. For more detailed areas, pencil points were sharp. Dull pencil points maximize texture, sharp points minimize texture.

PENCIL EXTENDERS OR LENGTHENERS

This tool is a must, and experienced artists often have a dozen or more on hand. It is a wooden, pencil-like shaft with one end containing a metal ferrule and locking ring. It adds length to pencil stubs that are too short, giving them additional mileage. Buy two or three of these and add more as time goes on.

FIXATIVE

Wax-based colored pencils, when heavily applied to a paper surface, will exude excess wax, creating a hazy or foggy appearance over these particular areas. This is called "wax bloom" and can happen in about four to seven days. It can be carefully wiped away with a soft cloth or facial tissue, but will return unless sprayed with a fixative.

The trick for using fixative successfully is to spray with several very light coats, rather than a single saturating one. Fixative, being a solvent, can quickly intensify colors. And while this may sound like a desirable effect, it really is not. For the result of too heavy a spraying is blotchiness and unwanted color shifts.

Wax bloom can be seen at the left side of the sample. At right, this film has been wiped away with a soft tissue.

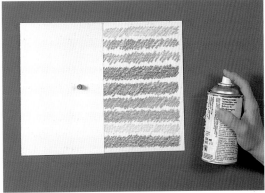

Before first attempting to spray a drawing, lay out rows of colors, fold to expose only half the rows, and spray them lightly on a vertical surface.

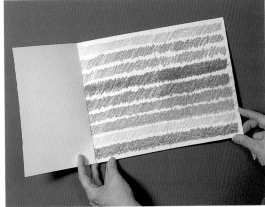

Unfolding the sheet will reveal which colors were affected. Rows marked with an "x" were unacceptably changed.

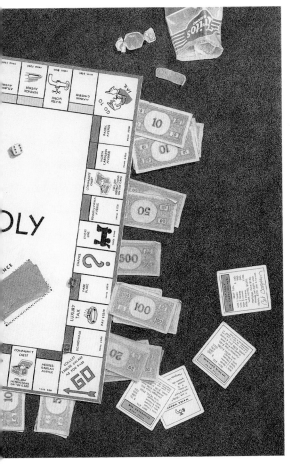

Setting Up a Workspace

Much too much has been made in recent times of the studio as a showplace. It is as if given enough effort, enough decor, enough impressiveness, all the other problems of making art will take care of themselves. Sadly, this view of the art process as beginning with "studio adequacy" lures many a new artist into wasting a lot of time and money. The fact is, art resides within each artist. It does not need a carefully arranged setting, however spare or elegant in design, but can happen just as readily at a modest table.

Having your tools and materials near at hand is of course convenient and desirable. And having a dedicated space for your work does send a message to spouse or family that you are serious. With the colored pencil medium, neither a whole lot of equipment nor a great deal of space is needed. The first three things you will want for a serious beginning are:

- A room or space within a room that can be adequately lighted.

- A drawing board or drafting table and chair.

- A taboret or utility table for pencils, sharpeners, and other small stuff you will frequently use.

That's about it. Later and gradually you may want to add:

- A light box or light table.

- A metal or wood cabinet with large sliding drawers for papers and boards, and finished and unfinished drawings.

- A paper cutter (as large as you can afford).

- A vertical slot system for storing framed work.

- A table for matting and framing.

My home workspace is now over twenty years old. It began life as a place to paint with oil, and was arranged to house a large easel. Over the years as my medium of choice changed, so did this workspace. It is now totally functional, without decor, and if it conveys any mood at all it could only be described as "no nonsense." It works well for me. My equipment is described, in detail, on the facing page.

WORKSPACE LIGHTING

You will note that good lighting topped the above list. It's important to match your workspace lighting to your work's most likely future home so that the color nuances you have worked out will have the best chance of remaining visible. If your pieces are to hang in residential environments, the light here is usually "soft white" incandescent mixed with ambient window daylight. Large commercial spaces, on the other hand, tend to be lit with a combination of warm and cool flourescent light. Try to approximate these lighting conditions. And avoid drawing and mixing colors under the so-called "color corrected," or "full spectrum" lamps, unless you are pretty sure that one of these is truly the lighting your work will hang in.

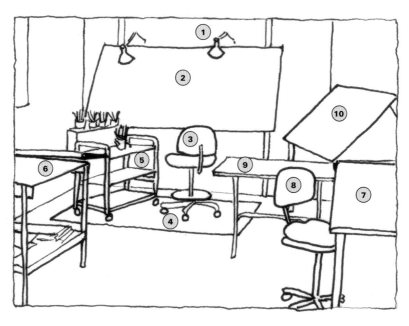

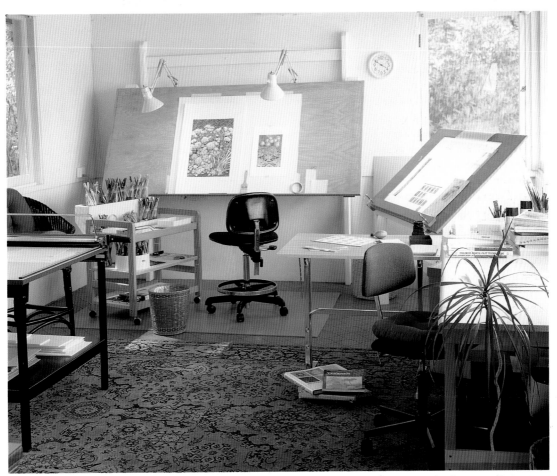

1. The *directional lamps* hold 100-watt soft-white incandescent bulbs. I keep these high off the work to avoid distorting color. Overall, my studio space is lit with about 800 watts of incandescent lighting mixed with quite a lot of ambient daylight.

2. My *drawing board* is a hollow-core door hinged to a wall frame and adjustable for height as well as for angle. I usually set it almost vertically to see my work better.

3. A *rolling desk chair* lets me move backwards from time to time to view my work from a distance. Working at a high drafting table with a stool has two disadvantages. One is seeing work only obliquely, another is being unable to view it from a distance.

4. Most home workspaces are carpeted, so a *sheet of hardboard* beneath taboret and chair makes for smooth rolling, as well as for protecting the floor.

5. My *taboret* began as an unfinished TV stand, to which I added a second tier and an extra middle shelf. Any wheeled table or small cabinet might serve as well.

6. The *paper cutter* is a freestanding machete type, big enough for full-sized mats and drawing papers.

It was added after years of using a smaller cutter, and is a great luxury.

7. My *studio desk* is really a kitchen countertop without a sink cutout, seated on a wood frame with 2 × 4" legs.

8. I use a *second chair* with my studio desk.

9. A *small utility table* has dozens of uses. I like table surfaces better than shelves or cabinets. This junior drawing board has served as companion to the light table, extra drawing board, desk extension, and still life setup table, among other duties.

10. I first used a small homemade lightbox to transfer guidelines onto final drawing paper. As my work became larger I needed a *full-sized light table*. This one is homemade, with a clear sheet of glass over a frosted sheet of acrylic. Light is supplied by four flourescent tubes in a pair of four-foot shoplights. While manufactured lightboxes and tables usually produce light of a "daylight" (5500° Kelvin) rating, mine does not, but is equally useful for my purposes, and more affordable. It is shown here tilted up at an angle, but is usually positioned flat. Not shown are a matting table, a metal cabinet with flat drawers for paper storage, and a closet for framed pieces.

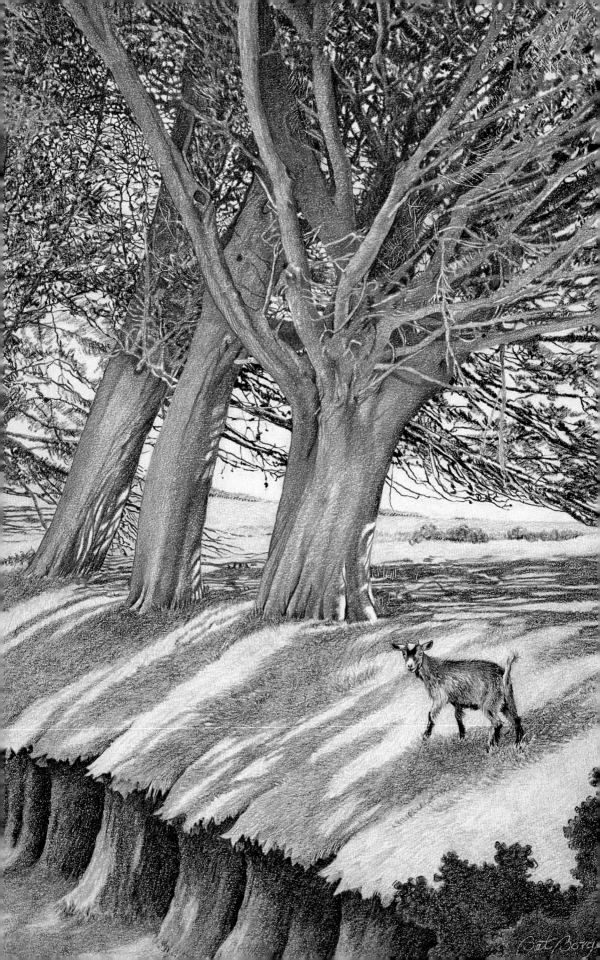

Fundamentals

Kinship. When we study the essential principles of art, we declare our connection with the artists who have come before us. Every good artist must continually examine and refine the ideas and vocabulary of how art is accomplished.

Reflecting on basic tenets is more than a nod to the past. It is an acknowledgment of our important antecedents, and how they accomplished the kind of work we hope to produce. As we better understand what came before us, we become a part of this enduring continuum.

In this chapter, we'll be dealing with some fundamentals: drawing, color, form, volume, space, composition, and more—and how these things relate specifically to the colored pencil medium. We'll identify various idiosyncrasies here—the medium's peculiarities in color mixing for example—and offer ways of working with them more effectively.

YOUNG GOAT
Colored pencil on Rising Museum Board, $19^1/_2 \times 14^1/_2$" (50 × 37 cm). Collection of Washington State Arts Commission, Art in Public Places program in partnership with Mabton School District.

Colored pencil's potential to deliver both drawing and painting qualities simultaneously can be clearly seen in this piece, as detail and broad sweep are fused.

Drawing

Students often ask how much drawing skill is needed for working with colored pencils. The answer is, no more or less than for any other medium. What we need is enough skill to get the job done within our intent and our personal style. For this, some artists seek a thorough and formal understanding of artistic draftsmanship. Others depend on narrative and emotive strengths, and assign draftsmanship to a secondary role. In art, many ranges of excellence can exist side by side, and all can be legitimate.

TWO DRAWING APPROACHES

Whether engaged in realistic or representational (less realistic) drawing, today's student will encounter two wellsprings of knowledge that often seem antagonistic to each other. The first of these derives from artistic conventions formulated by master artists during the Renaissance to achieve effective illusions of reality. The second approach relies on the idea of drawing what is objectively seen, without any overlaying of intellectual concepts that interfere with true seeing.

But trying to separate these two approaches is really a false issue. While the conventions of the masters are often necessary to effectively communicate realism, the drawing-what-you-see approach is also necessary for putting aside preconceptions about what is being seen. Both are useful, interactive, and can be freely combined.

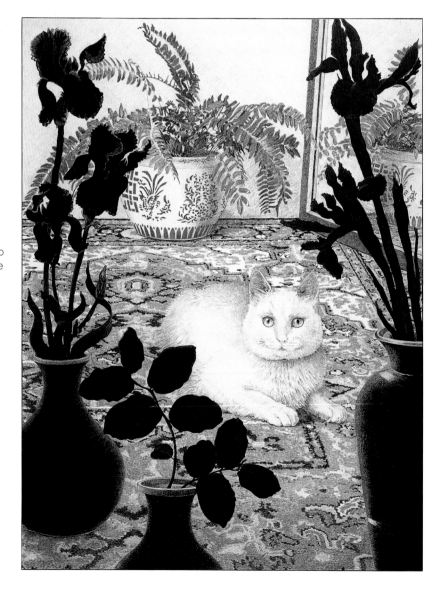

PLEASURES
Colored pencil on Rising Museum Board, 24 × 19" (61 × 48 cm). Collection of the artist.

Draftsmanship has never come easy to me. Yet, I am always attracted to taking on imagery as complex as this oriental rug. The challenge with this kind of subject is to sort through its profusion of visual information, then to clarify and simplify it all. I see drawing as an artist's first opportunity to begin this process. While continuing judgment is needed throughout a work's progress, early decisions and marks made for a drawing will probably set whatever level of spareness or extravagance that distinguishes it from that point on.

ARTISTS ARE NOT CIVILIANS

As the realization that art is meaningful to you grows, and you come to believe you want to be a lifelong practicing artist, you will begin to sense that you are no longer a "civilian." "Civilians" don't practice drawing. They don't study color, or reflect on the nature of visual illusion. Furthermore, a "civilian" does not have to know the technicalities of what graphic effects will work and what will not, as an artist must. Confronted with a compelling scene or event, a "civilian" may feel it strongly. But he or she is not likely to additionally feel compelled to interpret it, infuse it with meaning, then visually communicate it to others.

Drawing, for artists, is a way of life. It is a fast- or slow-moving race with no finish line, no diploma or license to prove that you have arrived at some certifiable level. Your needs will shift and change, and you may even have to reinvent your skills from time to time. Keep drawing.

PRACTICE FREEHAND DRAWING

Advice to practice freehand drawing (using no aids) seems at odds with today's frequent taste for instant success. It may gain a higher priority when you consider that when you draw freehanded you are—maybe even more importantly—learning about the following:

- values
- plane changes
- form, volume
- movement, direction
- proportion
- spatial relationships

No amount of photographic tracing can teach you these things as well as can freehand drawing. As a beginning, draw from nature. Select things that engage you. You will draw better sooner if you have strong feelings about your subject. Also, try to work into your drawings the kinds of visual clues that communicate ideas. For example, while looking at a real box try to draw and suggest the following:

- a slumping box
- an excited box
- a sphere posing as a box
- a dark box in darkness

In addition to manual drawing practice, try visualizing images and forms while deeply relaxed or before falling asleep. Try to clearly visualize as many orders of detail as you can, from overall gesture to subtle textures. This takes practice, too. But when you can hold a form in your mind's eye, then slowly revolve

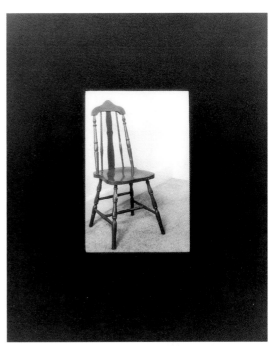

With its right-angle context, a viewfinder can show vertical, horizontal, and proportional relationships. When an object is placed close to a viewfinder's edge, such as the chair in this photo, its angles are immediately better understood. Any device with at least one right angle will work, so long as it is held and viewed in a true vertical plane.

it to get different points of view, you will be miles ahead of where you began.

PERSPECTIVE

I have never known an artist who used perspective the way it is taught formally. Instead, artists tend to draw things that are consistent enough with perspective so that the effect is not jarring. Contemporary treatments in fact often dramatically depart from rules of perspective for emotional impact.

There are also many artists who don't quite see things the way others do. It would be counterproductive for such artists to attempt conforming to a system for which their personal sensory systems are not equipped. Distortions of this nature, so long as they remain consistent, can be not only engaging, but a positive trademark of the artist.

In general, a good approach to perspective is to familiarize yourself with its main thrusts. Rely on good observation to see you through difficult features, such as foreshortening or multiple angles. Using a rectangular or L-shaped viewfinder can greatly simplify this process, and help you better see vertical, horizontal, and proportional relationships.

Color and Drawing

Unlike most other mediums, colored pencil resembles both drawing and painting. But with this ability comes a challenge. Drawing is considered an intimate idiom, to be best viewed close up. Painting, however, can often be best appreciated from a distance.

The task for successful colored pencil work is to combine these seemingly opposite requirements. It is as if a good colored pencil drawing must actually contain two drawings. The one that is to be seen from a distance must depend on strong simple masses of color. The other, to be viewed close up, is the one containing all the subtle color nuances for which good colored pencil work is best known. It is very important to remember that when you sit and draw you are actually working on the close-up version. To fully develop a drawing that reaches out to a viewer across a room you must occasionally push your chair back or stand back and away to assess the progress of your "other drawing."

Most artists attracted to colored pencil like to draw. They appreciate the precision and control possible with a pencil point. What they often

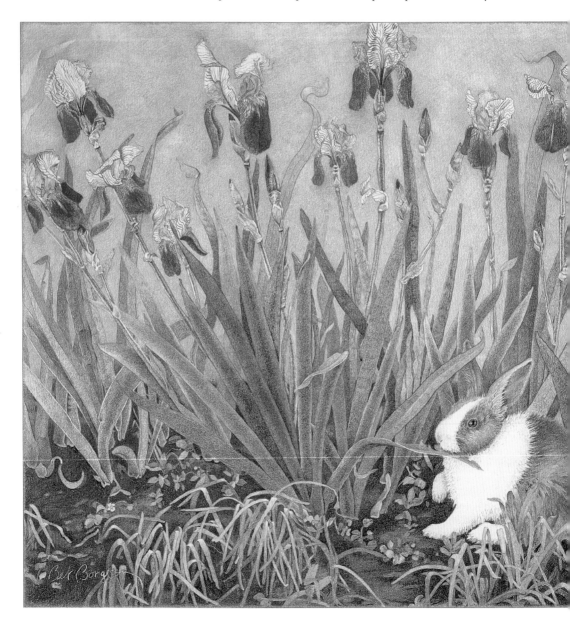

overlook, however, is the crucial role of color in fully engaging both aspects of this medium.

PENCIL COLOR AND COLOR BASICS

The distinctive features of pencil color have a particularly unique relationship to traditional ideas about color basics. For example, pencil colors do not have complementary pairs, as the colors of other media do. There are other idiosyncrasies about them too. To understand colored pencil colors, let's review the fact that each and every color we see and experience has these three dimensions—hue, intensity, and value—plus temperature. Here is how colored pencil relates to color basics:

Hue. This identifies, by name, the colors of the visible spectrum—blue, blue-violet, violet, and so on. Hues have an order, and can be arranged around a color wheel. Color wheels vary, depending on the era of their devising. But all provide insights into how different hues relate to one another.

Such mediums as oil, watercolor, and pastel have traditional color formulas, and names that have remained much the same for centuries. There are cadmiums, cobalts, the raw and burnt earths to name a few. Although manufacturers at times have played with variations and additions, the hues are basically standardized.

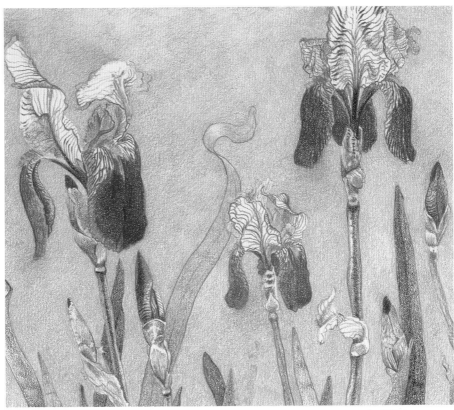

RABBIT AND IRIS (DETAIL)
Colored pencil on Rising Museum Board,
19^1/$_2$ × 25^1/$_2$" (50 × 65 cm). Private collection.

RABBIT AND IRIS
Colored pencil on Rising Museum Board,
19^1/$_2$ × 25^1/$_2$" (50 × 65 cm). Private collection.

Colored pencil artwork really contains two drawings in one. The first is that seen from a distance. This drawing is over 25 inches wide, so seeing it at this size is like looking at it from across a room. Its impact at this distance depends on its large, simple masses of color. Viewer reaction must come from the composition of these color masses.

When a viewer becomes interested enough to move closer, another drawing reveals itself, this one with more subtle information. Flowers that at first seemed simply blue-violet are now seen to be blue, violet, purple, and scarlet. Other close-up changes will be found everywhere.

With colored pencils this is not true. The colors *do not* conform to traditional standards. Because the pencil colors are more mixed, less pure, their names describe manufacturers' mixtures, such as Prismacolor's parrot green, or Lyra's wine red.

Intensity. This term, also called saturation, describes the purity of a color as regards its vividness or dullness. A hue of high intensity or strength appears vivid, with a simple and straightforward quality. A hue of low intensity appears dull but may have more resonance. (The word *dull* in color usage is not a pejorative, but merely describes the opposite condition of *vivid.*)

Most colored pencil colors are of low to medium intensity. Pencil colors of truly high intensity are rare. This is actually not the disadvantage it might seem, for these kinds of colors can be easily combined in complex and subtle mixes.

Value. This refers to the lightness or darkness of a color. It is the only dimension of the three that can also exist outside of color (as a neutral: white, gray, black). Value changes alone can make a form appear three-dimensional. Bringing hue and intensity changes into play reinforces this effect.

All colored pencils have an inherent or built-in value. The darkest value any single pencil can express can be seen by just looking at the value of its lead. Most pencil colors fall into a range of medium values. Because of this, other pencils must often be enlisted to darken what is inherently a medium or light-valued pencil.

Temperature. Color also seems to us to have temperature. The hues near red, we consider warm; those near blue, cool. When layering colored pencil, the top layer will roughly determine temperature, but the final determinant of this will be context.

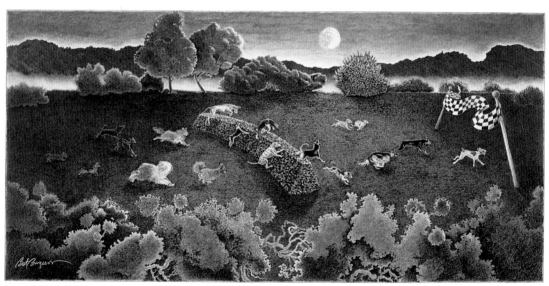

NIGHTRUNNERS
Colored pencil on Rising Museum Board,
15 × 31" (38 × 79 cm).
Collection of Washington State Arts Commission, Art in Public Places program in partnership with Tonasket School District.

In this whimsical night landscape it was important to achieve a look of reality for the racing dogs in order to help "sell" the very unreal nature of other aspects of the drawing, such as the vegetation in the foreground, which acts as a surrogate for a cheering crowd.

To communicate early evening, I lowered the intensity and value of all colors except the sky. In dark landscapes there must be a lightened area to point up the subject. To create drama, to focus a viewer's attention, and to suggest something special happening, I included a kind of spotlight effect by lightening color values in a pyramidal swath seeming to emanate from the moon.

Four dogs on the extreme left had to be very de-emphasized. To make this happen they were darkened so that they barely emerged from the gloom. This is often a difficult thing to do for those who like to draw detail and who have fought hard for good draftsmanship. It seems as if these skills are just being thrown away. It helps to realize that with de-emphasis as well as emphasis you are still using full drawing and judgment skills.

Mixing Color with Colored Pencil

As previously noted, the colors available in most other mediums are basically pure, with many at full spectrum strength. These colors—being more or less standardized—can be mixed in fairly traditional ways. With colored pencil, however, the colors available are not of the traditional kind, but come to us already mixed. Rarely does a colored pencil color have a level of purity that will correspond exactly to spectrum strength. When we mix pencil colors we are actually *altering, modulating,* and *intensifying* our premixed colors. And it is especially important for consistent and predictable results that we mix our pencil colors with as much specificity as possible.

Let's look now at how color is applied. There are basically two ways: by layering—superimposing a solid area of color over another; and by juxtaposing—arranging colors (solid areas, lines, or marks) side by side. In practice, both methods are frequently combined.

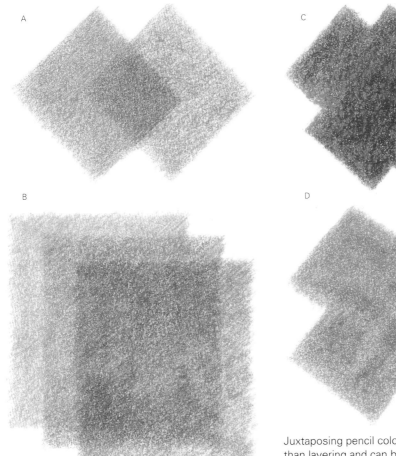

A

B

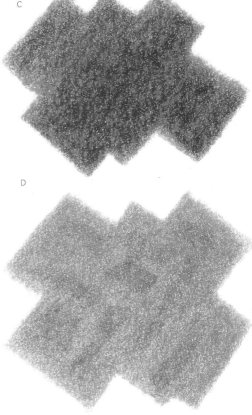

C

D

Line is fundamental to drawing, but is a poor vehicle for delivering color. So we use solid areas of color along with line, or leave out the line altogether. Colored pencil color is transparent so we can layer or superimpose solid tonal areas for rich and complex colors. The top sample here (A) is made with two colors uniformly combined. The three colors below it (B) are more loosely combined, which adds vitality.

Juxtaposing pencil colors in a single layer is faster than layering and can be just as rich and engaging to look at. Juxtaposed colors can be made up of small fragments (C) or can be larger areas of color (D). There are, in fact, no limits to how and when colors can be successfully juxtaposed. While drawing, it is advantageous to combine complete layering, partial layering, and juxtaposing. For most artists there seems little if any reason for using beyond three or four layers of color ever.

ANALOGOUS MIXES INTENSIFY PENCIL COLOR

Although most pencil colors, being premixed, are of inherently low to medium intensity, we sometimes need colors that are more intense. By combining hues that are analogous or similar—those hues normally clustered together on a color wheel—we can increase, or at least enhance, the resulting intensity.

Usually, when two or more of anything are combined, the resultant purity is lessened. But oddly enough, when two similar colors are mixed (two different reds, or a red and an orange, for instance)

there is an apparent optical effect of heightening rather than a reduction of intensity. To gain this effect however, it is necessary that the analogous group used be all of similar temperature. Colors do not effectively remain analogous if opposed in terms of warm or cool.

An additional benefit of using analogous colors in this way is that some pencil colors that are naturally intense can appear harsh. Analogous mixes on the other hand can frequently offer an appearance of similar intensity without the stridency.

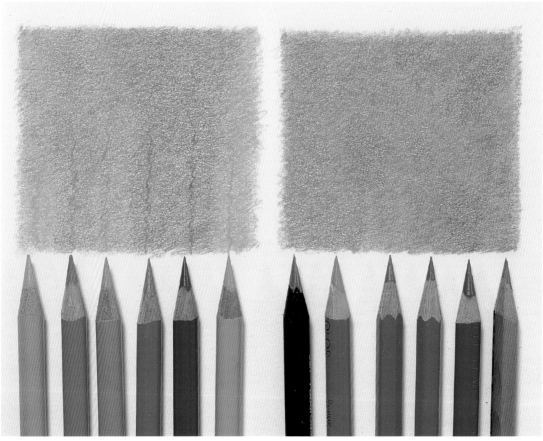

All the pencils shown are analogous. The group at left—mixed with layering and some juxtaposing—is made up of red, red-orange, and orange hues. They are (from left) Prismacolor 918 orange, 1032 pumpkin orange, 921 pale vermilion, 922 poppy red, 925 crimson lake, and 929 pink. The group at right is made up of all reds, but from various manufacturers. They are (from left) Design Spectracolor 1403 crimson red, Prismacolor 926 carmine red, Caran d'ache 3888-080, Bruynzeel 438, Prismacolor 924 crimson red, and Lyra 600-26 dark carmine. This second group was juxtaposed in a single layer with only a minimum of overlapping for blending.

NEAR-COMPLEMENTARY MIXES MUTE COLOR

Useful as analogous mixes are, they can sometimes appear somewhat lightweight or insubstantial. A possible reason for this feeling about them may be that analogous mixes and color schemes have become so ubiquitous in commercial products that they are overly familiar to us. Near-complementary mixes and schemes are much less so. These often seem to offer an ironic combination of great delicacy and heft.

Hues that are exactly opposite one another on a color wheel are said to be complementary, and when combined result in gray. But in this medium, as earlier noted, there are few if any such complementary pairs. Manufacturers of colored pencils compensate for this by offering many separate grays. What colored pencils have are near-complementary pairs. Mixing these can produce some of the medium's most sophisticated and tempered colors. Most of the muted colors found in nature in fact can probably be more accurately rendered with these near-complementary blends of color than in any other way.

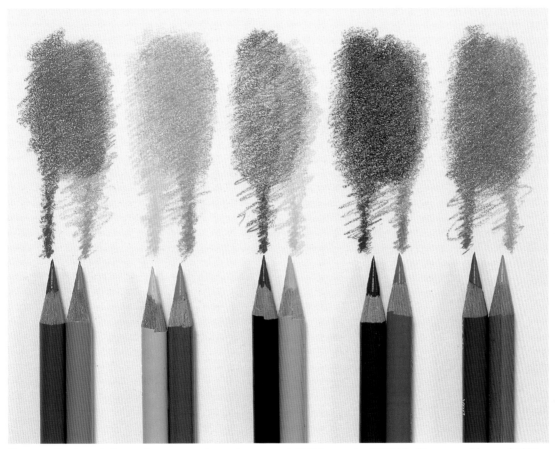

Here are five loosely layered, near-complementary mixtures that seem to fall between segments of a color wheel. Some colors don't really have names. Others are identifiable, but muted. The mixtures are (from left) Prismacolor 1022 Mediterranean blue and 1034 goldenrod; 927 light peach and 1020 celadon green; 932 violet and 1003 Spanish orange; 906 Copenhagen blue and 923 scarlet lake; 1006 parrot green and 929 pink.

A Colorist Approach

If we could make lists of the pitfalls in using various art mediums, a pitfall topping the list in the colored pencil medium would be this: the drawings of many artists working in colored pencil celebrate draftsmanship with little regard for color. The irony is that many who love to draw are attracted to this medium because it is a color medium. But while working with it, the artist's thinking remains in black and white. And work produced relies more on value changes than on color's many other qualities.

It is important to remember that using color instruments for artwork does not guarantee successful color effects. Colorists—those who recognize and use color's properties well—come closer to this. We begin putting color to work when we realize that besides being flat out decorative, color can perform many functions. It can, for instance, do the following:

- Evoke mood and emotional reactions, or reinforce attitudes.
- Delineate form and emphasize (or de-emphasize) features of forms. (Values among elements are sometimes so similar that only hue contrasts can separate their identities.)
- Reinforce three-dimensional modeling of form.
- Aid in establishing spatial relationships.

WALKING MERIT HOME (AFTER HENNINGS)
Colored pencil on Rising Museum Board, 22 × 27" (56 × 69 cm). Collection of Washington State Arts Commission, Art in Public Places program in partnership with Bethel School District.

Color was used to reinforce the drawn spatial structure in this piece. To help push back trees in the far distance, their details were generalized and their colors were kept cool. The pinkish vegetation in the middle distance is warmer than the distant trees and has a little more vividness. The colors of foreground elements—the tree bark and leaves, the drafthorse and his handler—are in focus, drawn with more realism, and with colors decidedly warm to establish a foreground location.

EFFECTIVE COLOR DEPENDS ON TWO TASKS

It is my belief that creating superior color passages can be divided into two tasks. The first of these is learning to accurately see local color in real life, to practice at recognizing a thing's simplest color component or hue family. For example, is a red rose really red, or is it more truly a blue-red or an orange-red? More difficult things—water in a river perhaps—may be not as preconceived, but the color of a reflected sky or riverbank. Or if shallow enough, its color may borrow from the sand and pebbles over which it flows.

The second task, once a color's simplest hue component has been identified, is to modulate this color in order to bring into play one or more of color's functions. More about such functions, and how to manage them, will be dealt with as we discuss form, volume, and space.

INCREASING YOUR COLOR SENSITIVITY

Where color is concerned, we as consumers may have a special burden. We have all, more often than not, been aculturated to appreciate a certain kind of benign color harmony that is dictated by today's marketplace. It is a color patness—made up of overly familiar and easy-on-the-eye combinations. It is everywhere—in linens, on clothing, home and office furnishings, cosmetics, even in the cars we drive. But the colors of fine art cannot be based on banal or commercial formulas.

Increase your sensitivity to color and to more robust color schemes by starting to look at things in your environment, things you have been taking for granted. As you drive your car, identify the true color of the streets. Is asphalt really a dark gray? Or is it more a steely-blue, or a blue-violet of low intensity? Do its colors change under differing skies and times of year? Tree bark, as another example, can have a very wide range of curious and unexpected colors, once it is no longer preconceived as brown.

It sometimes helps to use a simple cutout in a large card as a viewfinder to isolate the colors of objects and to see them more objectively. It also helps to study the colors of the masters. An isolating viewfinder is helpful here too in seeing some of their color subtleties.

**WALKING MERIT HOME
(AFTER HENNINGS)
(DETAIL)**
Colored pencil on
Rising Museum Board,
22 × 27" (56 × 69 cm).

In addition to using color to reinforce overall feelings of space, it was also used to help manage the drafthorse's massive three-dimensional presence. Cool colors were added to his rump, and opposing warm colors to his chest, neck, and halter to bring his head nearer the picture's front plane.

DARKENING LIGHT PENCIL COLORS

Artists new to colored pencil often make drawings in which all the values expressed lie in a light to middle range. Such drawings ignore a full third of this medium's available richness. The primary reason for pale looking drawings (when unintended) is that some artists mistakenly believe that values can be darkened by simply pressing down harder on the pencil. The result is not a darker passage, but merely a waxier and shinier one.

To correct this it is necessary to add one or two dark pencil colors to the color being darkened. Black is not the best choice for this task. Being devoid of hue itself, it usually deadens color. Passages of color are much more effectively darkened with other darker colors. I tend to think of Prismacolor's 901 indigo blue as a universal darkener. To minimize changes in hue of the original color while darkening with indigo blue, it is sometimes necessary to lay a buffering color between them. This works best when the buffer is the darkest version from the hue family of the original color. For example, to darken a 924 crimson red, first layer some 931 dark purple over it, then add the 901 indigo blue.

Prismacolor 901 indigo blue (A) may be the darkest of all colored pencils, so it can deliver practically any value, depending on the amount of pressure used. It is often used to help darken other pencil colors.

A medium value pencil is the 924 crimson red (B), which delivers only the medium value shown, even with maximum pressure. Most colored pencils from all manufacturers fall into the medium value range, and are usually darkened with the 901 indigo blue pencil or, more often still, with a combination of indigo blue plus the darkest member in the hue family of the original medium value pencil. This method is shown at (C). First 924 crimson red was applied, then 931 dark purple in the area to be darkened, and finally 901 indigo blue over some of the 931 dark purple.

Darkening yellow is a very special case. Three methods are shown. The color 916 canary yellow was darkened with black (D) with a 6B graphite pencil (E). While graphite doesn't yield the darkest yellow, it is sometimes useful because it mixes so smoothly with the waxy yellow. The yellow sample (F) may be the richest, however, as real hues were used. First, a 1406 dark violet from the Design Spectracolor line was used over the 916 canary yellow, then 901 indigo blue over that. An in-between color is necessary when using indigo blue as a darkener of yellow, or the mixture will end as a green.

Tip

Try clipping a scrap of paper with black or 901 indigo blue applied heavily on it to each drawing when you begin to work. Do this for around six months. This will serve as a constant reminder, as you draw, of what a real dark looks like, for it is easy to convince oneself that a medium is a dark when there is no nearby key for comparison.

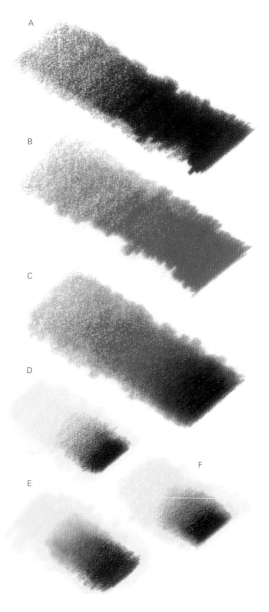

Creating Illusions of Form, Volume, and Space

Here is where drawing and color come together. The more you care about realism, the more you will need adeptness at creating illusions of three dimensions on a two-dimensional surface. And if you choose to rely heavily on photographic references, your success will also rely a great deal on your being somewhat of a magician at blending the cranky one-eyed reality of the camera with three-dimensional effects.

Let's start out here by defining some terms:

- *Form*. The shape and structure of anything that occupies space. A form can be flat, or it can have volume.

- *Volume*. This can describe any three-dimensional space, whether solid (like an apple) or hollow (like a room). For our purposes, we'll use volume to mean an appearance of solidity and mass—what the UPS clerk calls girth.

- *Space*. An infinite extension in all directions. We sometimes link space with depth, as with deep space, or shallow space. Visual artists create an illusion of space by putting forms into it. Without form of some kind, space cannot be perceived.

ART IS NOT REALITY

Before becoming experienced as artists, we think that striving for a convincing realism depends on our skill at duplicating reality exactly, with no editing or additions. The truth is, we as artists are not creating (nor even re-creating) a reality, but are instead trying to create an *illusion* of reality. This is a very big difference. What we call reality is so compelling that even though it usually gives us a confusing array of visual information, we still accept and believe it. But when we take reality's information out of its context and try putting it on paper or canvas we soon begin to see confusion. An artist must change information in order to communicate it as reality.

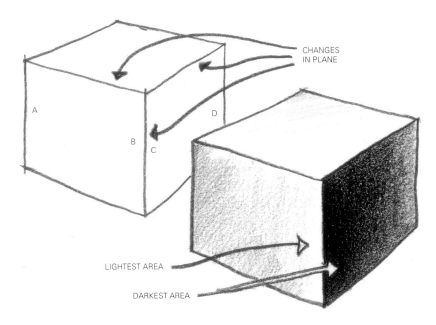

CHANGES IN PLANE

A

B

C

D

LIGHTEST AREA

DARKEST AREA

Learning to convincingly model forms in color begins by looking at how form is expressed without color. It comes as a great surprise to many to discover that even the most realistic of artists seldom draw what is actually seen. What is actually drawn is a blending of direct observation with a knowledge of certain artistic conventions. This is because the light under which we see most things can confuse and minimize form as well as reveal it.

Modeling with light and shade is simple when plane changes are abrupt. The lighting on the cube above is shown growing progressively lighter (A to B), and the shade growing darker (D to C). The greatest contrast occurs where these two planes meet.

A similar treatment of light and shade is used in modeling nonangular shapes, but plane changes are rendered less suddenly. The darkest shadow occurs somewhat past an imaginary meeting of planes, in what is called the core shadow.

Compare the more subtle plane change on the cylinder's face with that on the cube. Notice how easily our sphere could become an egg, an apple, or an eyeball.

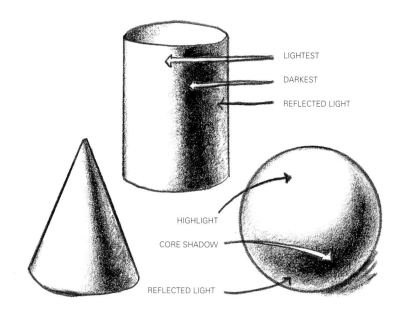

LIGHTEST

DARKEST

REFLECTED LIGHT

HIGHLIGHT

CORE SHADOW

REFLECTED LIGHT

The forms of this face—a sketch made after a Rubens study—are more complex than those above, but if you look closely you will find similarities. There are spherical shapes in the cheeks and chin, in the eyes and beads, and in the head as a whole. The nostril side facing us shows a progression of highlight to core shadow to reflected light. There is practically no likelihood of this actually having been on the model's face. These things have been added as visual clues to describe the surface topography.

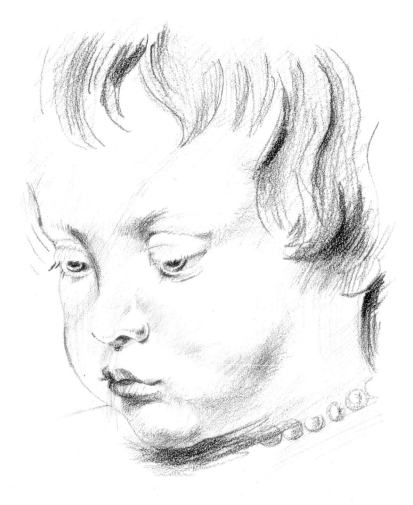

Most artists are aware that our formal tenets of perspective were invented by master artists during the Italian Renaissance. What is less well known is that these same masters also gave us a very complete system for creating illusions of form and volume. Although we live now in a period that seems to celebrate personal observation over all else, the classical tenets of drawing form and volume can be neatly joined with it. Here is how classical modeling works:

Illusions of form and volume are created with systematic changes in value (the lightness/darkness scale). From the simplest geometric to the most complex of natural forms—all are expressed by use of a steady progression of value from light to dark. The specific order of these changes is: highlight, light, shadow, core shadow, reflected light. Try to remember this progression. Almost every accomplished artist of the past has memorized these rules for changing values to construct forms.

Because this classical modeling of form, called *chiaroscuro*, is value oriented, it can be expressed in black and white or in colored values. Later artists such as Chardin and Cézanne began to also use color's dimensions of hue and intensity as well as temperature to model form and create space. They did not abandon chiaroscuro, but added to it color's own abilities to advance and recede.

ADVANCING AND RECEDING COLOR

Certain color conditions can seem to push a color forward or backward. This apparent movement of color, when constructed and wrapped around a form, can reinforce value changes to create a more credible three-dimensional illusion. When movement of color is placed among elements, rather than being wrapped around a form, it can suggest spatial distances—shallow or deep. Here are some color conditions that seem to advance:

- warm
- high-intensity
- light in value
- isolated, unrelated color (not visible elsewhere)
- line(s), outlines
- coarse texture or texture in sharp focus
- patterns
- active, busy color (having many variations)

Color conditions that seem to recede are generally of an opposite nature. Some of these are as follows:

- cool
- low-intensity, muted, dull
- dark
- closely related colors
- tonal areas of color
- fine or generalized texture
- absence of pattern
- passive, quiet color (changes made slowly)

You will notice that the first three conditions describe color by temperature, intensity, and value. The other five describe color conditions by form or context (as in lines or patterns). It is worth noting also that an exception to the principle of light-valued colors advancing often exists in landscape work, where far vistas are lightened rather than darkened.

Making use of color's ability to seemingly advance and recede does not mean that all foregrounds must be warm and vivid, and all backgrounds cool and drab. It does mean that a coolish foreground element, for example, may need a warmed edge somewhere, or one or more other such advancing conditions to help it stay out in front. Context is always important, as all of color's conditions are relative to one another.

Let's look now at modeling with color. There are various ways for achieving this. In each of these sketches of pears, the idea is to establish a sense of form and volume. The small pear (A) does so without color, by modeling with light and shade. The next pears (B) show a tentative kind of color rendering, and this is a frequent beginning method for using color in drawing. But what are we really doing here? The two pears are essentially like the small black-and-white pear, but are executed with a color instrument. Color in this kind of drawing usually relies heavily on local color. It is a drawing method that can carry conviction, but tends to lack vitality.

Another method of color modeling (C) creates form and volume with intensities and temperatures of hues. Value changes are minimized. An impression of volume is created instead by contrasts between cool and warm color temperatures and between dull and vivid intensities. Cool/dull colors are placed where receding effects are wanted, and warm/vivid colors used for pulling planes forward. This is a dynamic and bold way of modeling form, but is also a somewhat rigorous approach.

In the last two pears (D), light and shade modeling (as in A and B) is combined with some color modeling (C). Value changes are used in the basic rendering of form, although (unlike B) local color is of less concern. *Additional colors were chosen not for literal accuracy but more for their abilities at helping forward and rear planes advance and recede.*

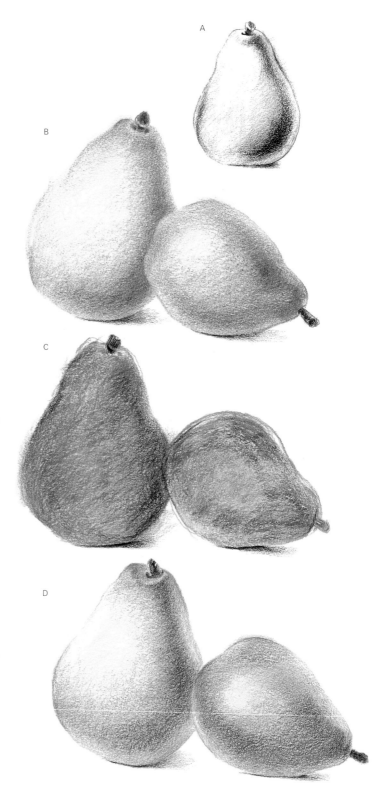

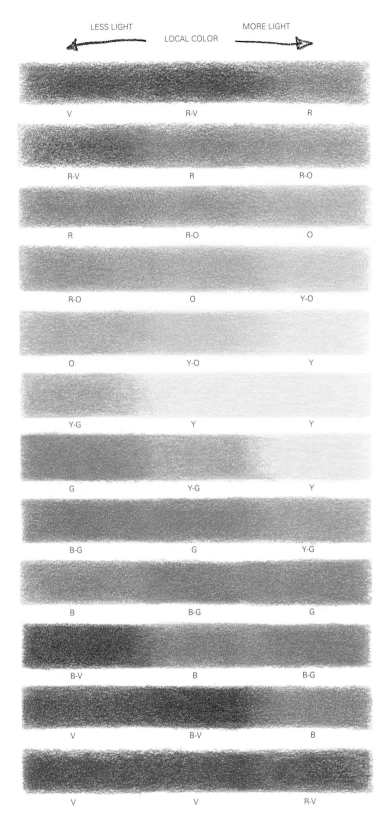

LESS LIGHT → LOCAL COLOR ← MORE LIGHT

V	R-V	R
R-V	R	R-O
R	R-O	O
R-O	O	Y-O
O	Y-O	Y
Y-G	Y	Y
G	Y-G	Y
B-G	G	Y-G
B	B-G	G
B-V	B	B-G
V	B-V	B
V	V	R-V

A color's hue is always affected by the amount of illumination on it. As light increases or decreases, the hue will shift toward its next warmer or cooler adjacent hue on the spectrum (or color wheel). This phenomenon is of enormous importance in color drawing, for by understanding and using color to convey temperature, we can suggest the amount of light falling on any object, and thus better reveal its form.

If in drawing a sphere, for example, we show a progression of hue temperature changes—from cool to warm, then back to cool—we help express form by suggesting varying amounts of light falling on it. Combining this concept with changes in value can yield a convincing, as well as engaging, depiction of form and volume.

Shown here are the shifts in color temperature found in a standard twelve-hue color wheel.

Composition

Composition is the arrangement of shapes into a unified whole. Put another way it means using or altering elements to make a point. It is composition that most links visual art with theater, music, and storytelling, and, like all of these, visual art at its best contains some kind of star performer surrounded by supporting players.

Various compositional formulas have been invented at different times. The idea has always been to guide the movement and pacing of a viewer's eyes, directing them finally to the piece's climactic focal point for an appropriate emotional reaction. In our own time, a composition may be based on intuitive, or free-wheeling methods rather than on rigid rules, so long as it achieves an artistic coherence.

To begin working with composition there are some basic considerations worth thinking about:

DIVISION OF SPACE AND SUBJECT PLACEMENT

- You will heighten your awareness of composition by starting with a frame of reference—a drawn border of horizontal or vertical shape, or of a square. Beginning a picture with a subject, then attempting to enclose it with a border, can lead to compositional (as well as framing) difficulties. For their structure and nature to be understood, drawn elements must relate to a frame of reference or picture plane. When experienced artists eliminate a drawn border, it is because they can maintain a mental picture of it that overrides the paper's edges.

- It is considered best to divide a composition into areas of unequal sizes. This means, for example, always placing a horizon line well above or below a picture's midline. Such unequal divisions are believed to be more dynamic. But this is a good place to also mention the fallibility of traditional rules. Experienced artists often regard them more as points of departure than as gospel. So avoid dividing a composition into equal parts—unless you want to address balance or symmetry, or want to counter this impact with an additional device.

- Avoid multiple centers of interest. This is not usually a problem with single subjects, such as portraits. It must be considered when working with such visually complex compositions as a narrative landscape.

- Avoid placing a center of interest in your composition's center. Artists sometimes like to use compositional devices. Among these are the "golden mean" and the "dynamic point."

- When composing a fairly simple drawing, try keeping your subject large within the picture plane, unless you deliberately want to communicate loneliness, isolation, or a primitive quality.

- Avoid letting shapes, even minor ones, encroach on or barely touch an edge of the picture plane. Either pull the shape back into the picture, or crop it at the edge.

- Avoid moving a viewer's eye right out of the picture by placing a single uninterrupted shape from one corner to an opposite diagonal corner.

- Try to make shapes—whether positive or negative—interesting. Avoid systematizing the outside contour edges of shapes, unless redundancy is part of your message.

- Be aware that shapes can form symbols you may or may not want. Archetypal shapes, those with universal meaning, can also influence a viewer's response. A pointy-shaped bird of paradise flower, for example, can look agressive or threatening rather than merely ornamental.

CONTRAST

Well-placed contrast is dynamic. A lack of it is static. Both are indispensable tools for expressing context and character in a drawing. Neither a lot nor a little contrast is more desirable as a drawing's dominant feature. It is the interplay between extremes that makes contrast most engaging. The most obvious opportunities for contrast are with values. Some other ways of creating contrast are:

- Color—with hue, value, intensity, temperature, schemes.

- Draftsmanship—with linear/tonal, edges, shapes, size/scale, texture, emphasis, generalization/particularization.

A still very pertinent comment on contrast, John Ruskin in 1857 in his book *The Elements of Drawing* wrote: "Great painters do not commonly admit violent contrast. They introduce it by stealth, and with intermediate links of tender change."

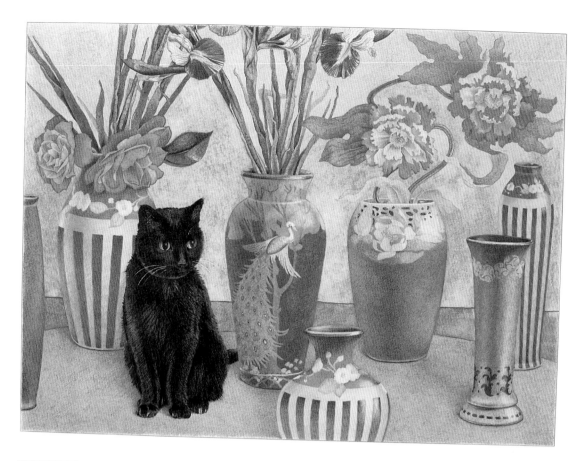

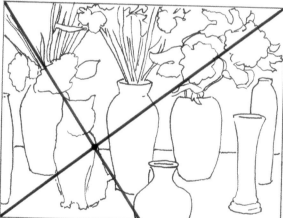

To find the "dynamic point" in a rectangular frame of reference, draw a line from one corner to its diagonal opposite corner. Draw a second line from one of the remaining corners to the midpoint of the longer opposite side. Where the two lines intersect (as shown on the line drawing of *Roseville Cat*) is the "dynamic point." Subjects don't necessarily need to be placed squarely here, but this method can be a useful tool when needed, and works also as a good guide for placing a horizon line or an important vertical line.

ROSEVILLE CAT
Colored pencil on Rising Museum Board,
20 × 27" (51 × 69 cm).
Private collection.

Amidst my studio clutter, a few scribbled notes for a drawing idea about a cat and some vases and flowers kept resurfacing. Nothing much ever came of it, probably due to multiple centers of interest and no real sense of unity. Then one day while riffling through an old catalog of Roseville pottery, I saw a strongly striped vase pattern that suggested the cohesive force needed for the cat idea.

To work out a composition, I placed the tabletop well below the middle of a rectangle drawn on a sheet of tracing paper. I next drew outlines of the cat and vases, including the three striped "super vases," on separate pieces of tracing paper. Moving these around for a strong arrangement—always mindful of space intervals in around the elements— I decided on this composition.

The cat, I feel, remains the focal point because it is conspicuously black. The striped vases form a triangle that helps unify the whole thing, and their patterns are strong enough to tie things together, but not so interesting in their repetition that they hold too much attention.

UNITY

This refers to cohesiveness or wholeness. It is hard to describe, but is somehow felt when lacking. Superior artwork, that which seems to have a presence all its own, contains unity. In such a piece there is a feeling of its composition being so inevitable that it could hardly have been better done.

As a way of thinking about unity, consider the possibilities of value alone. Suppose that with just the dark values there are three general arrangements: one peppered around, one that is isolated, and one that forms a linkage connecting different areas. Each of them has a character and an effect. You must ask yourself which of the three arrangements of the dark areas will best reinforce your theme. When they have been placed on this basis, in delicate balance with one another, and looking as if they could not have been properly placed anywhere else, you will have arrived at a unity.

IMPROVING YOUR SENSE OF COMPOSITION

It is an irony of the colored pencil medium that artists attracted to it often share a characteristic that leads to poor composition. And it is a positive rather than a negative thing that causes the problem.

We love detail. We are drawn to colored pencils for their sharpenable points and their potential for control. The more daunting a subject's complexity, the more happily we feel challenged.

Artwork conceived only from detail, however, can too often appear specimenlike, and lacking in broad or thematic context. With fine draftsmanship alone a drawing can end as merely a visual report of things. Art that succeeds must be more than this.

Avoiding this pitfall does not mean giving up the things that we cherish. What it does mean is thinking more about our subject before we begin. It means confronting our feelings about the subject, conceiving of a context for revealing these feelings, and then beginning to compose it all. A sense of dynamic composition can be acquired. Here is a good way of heightening your sense of good composition:

Find a few illustrated books on these European artists of the mid to late 1800s—Manet (not Monet), Degas, Cézanne, Van Gogh, Munch, Toulouse-Lautrec. These artists were all great composers. Like us, they had access to the art produced in earlier and diverse cultures. They also had access to photography. Their compositions were considered inventive and daring in their day, and remain so today.

But don't read about them. Your task is simply, whenever you can, to leaf through the illustrations.

Don't even read the captions. Don't try to analyze, or even to think too much at all. Just look at them over and over again.

What you want is visual exposure only. It doesn't seem too probable a method—but it works. If you do this you will become a better composer. Then as you look at your own composition you will seem to know almost instinctively when elements are not properly placed, and where they ought to be. Your new ability can develop quite rapidly, depending on how often you feed your compositional senses. If you feel weak in composition, give this method a try.

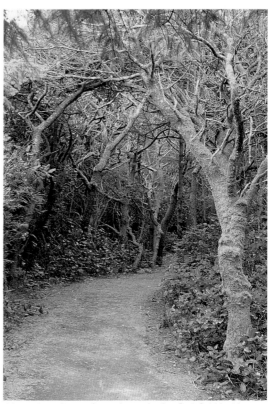

Above is a photo of a pathway in the Carl G. Washburne Memorial State Park, Oregon, which I used as a reference for *Looking Back* (facing page). A good illustration of what is meant by editing in art can be seen in *Looking Back*, together with its photo reference. When I first walked through this Oregon coast locale, I was struck by its feelings of isolation and beauty. Yet my reference photo of the scene did not at all reveal the broader, and possibly unseen, elements that engendered this mood. The photo seemed to compress the bare trees together, to provide far too much information about vegetation, and not enough about the surrounding low bluffs and overcast sky. This is exactly the kind of situation in which an artist must think about editing or altering elements that do not contribute to what he or she wants to express.

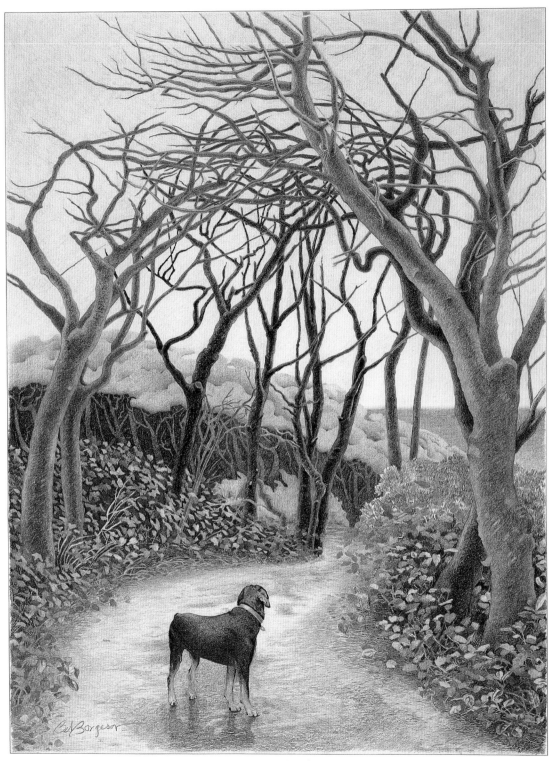

LOOKING BACK
Colored pencil on
Strathmore Bristol Board,
$26 \times 19^{1}/_{2}$" (66×50 cm).
Collection of the artist.

The Primal Nature of Edges

An extraordinary amount of artwork's meaning is packed into this one small word—*edges*. The character of edges—whether crisp, broken, harsh, outlined, diaphanous, and so on—provide visual clues of an almost primal nature to a viewer's sensory system. Edge quality can tell us whether something is stiff, flat, round, barely there, solid, or wobbly. It can also evoke conceptual or emotional states such as elegance, pluck, sensitivity, agitation, or brazenness, to name a few.

Edges happen wherever two forms, or a form and a negative space, come together. At each meeting point or passage the artist has an opportunity to express how these things interact, and to tell a little more about what is going on in the total piece. Imagine, for example, that you are drawing or painting a woman's portrait. As you begin work on the outside contour edges of your subject, you immediately have opportunities to express things—physical and emotional—about her. Where is she in space—right out in front, at a middle distance, or somewhat far back? With edge qualities as clues, you can place her solidly, almost mockingly, out in front, or show her as nearly invisible in her environment, and vulnerable looking. All this can be accomplished by the look and character of edges.

Powerful as the "edge tool" is, artists often overlook the opportunities it offers. And when photo references are used and copied too exactly, such opportunities are completely lost.

SINGLE PEONY NO. 3 (DETAIL)
Colored pencil on Rising Gallery
100 paper, 7 × 9¹/₄" (18 × 24 cm).
Collection of the artist.

If the importance of edges is a new concept for you, begin increasing your awareness—and your own drawing repertoire—by studying original work in galleries and museums. From a distance edges often look all the same. Looking closer, however, will reveal a surprising variety of edge qualities.

This piece (facing page) is a good illustration of what edges can do. Taken from Aesop's fable of the fox and stork, it is the scene where the too-clever fox gets his comeuppance from the stork.

My use of edges here began with my own ideas about the fable, which is that the animals are really there to act out a human story. And being actors, their botanical setting might be somewhat theatrical. This led to the idea of trying to give the whole thing a kind of mysterious quality. Here are how some of the drawing's edges were put to work to express these concepts:

- *Softly feathered edges.* The middle-ground mist. This edge (or in this case, lack of edge) is an important feature because it is so conspicuous. It is a horizontal lightness against a dark environment. Not only is it there to describe a diaphanous atmosphere, it also begins to convey associations of mysteriousness.

- *Crisply contrasted edges.* This edge occurs all over, but is most notable in the dark stand of tree trunks

at left. Other examples are in the foliage at right of the trees, the bluff silhouette next to it, the animals, and the orchids. In a dark drawing, contrast is critical to maintaining clarity.

- *Outlines.* Light-valued outlines are seen most prominently on the high branch that reaches out across the tree crowns, and on the orchid pseudobulbs and leaves midway on the tree trunk at right. Outlines flatten form. Using them sets up a note of unreality. Colored outlines can evoke theatrical lighting and colorless light-valued outlines can further suggest a kind of eeriness.

- *Crisp, low-contrasted edges.* This kind of edge occurs on the bluff between the stork and the orchid tree, on the dark path beneath the fox, and on both sides of the orchid tree. The main task of this edge is to de-emphasize. When crisply edged elements are low in contrast, they seem to acquire a quality of restrained power, and therefore a feeling of added tension.

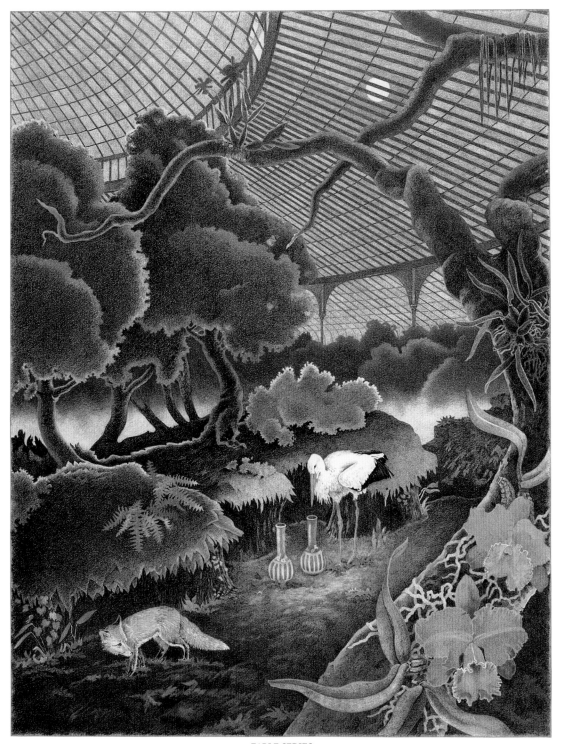

FABLE SERIES:
THE STORK'S DINNER
Colored pencil on
Rising Museum Board,
26 × 20" (66 × 51 cm).
Private collection.

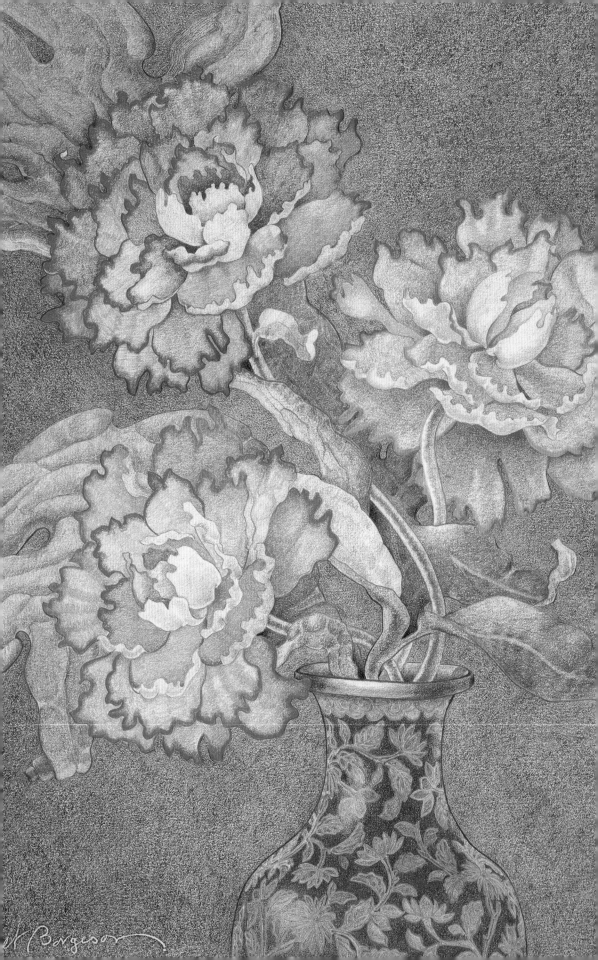

Getting Started

You've gathered together your needed materials, and now you're ready to start thinking about some fundamentals. You know you can do this. So let's get started.

In this chapter, we'll look at how to identify ideas, and what part inspiration plays in this process. We'll also talk about your options regarding photography as a source, and where and when you can successfully use it. The basic techniques of the colored pencil medium are also covered here—application, layering and juxtaposing color, color lifting, line impressing, plus some insights into texture control and ways to save time. After arming you with this important information, we'll guide you through a working procedure that is flexible enough for you to customize.

Finally, we'll discuss ways for you to appraise your own work in progress, so you can make adjustments and corrections that are meaningful and to the point. These new skills will enable you to finish each piece with confidence. It is my hope that you will see this chapter's philosophy and instruction not as a set of constricting formulas, but rather as a giant step toward your own idea- and process-building method.

THREE PEONIES IN PATTERNED VASE
Colored pencil on Strathmore Bristol Board,
16 × 13" (41 × 33 cm). Private collection.

Because colored pencil is a medium of texture, you need to rigorously maintain special point sharpnesses. To minimize grain texture and to allow better expression of color along the petal edges, I used sharp points and firm pressure. I switched to blunt points to maximize texture in the negative space. Textures seen in the other petal parts and vase lie somewhere between these two extremes. The pencil points were only sporadically sharpened, except in areas that were more detailed or needed clarification.

Ideas and Inspiration

As you get a handle on fundamentals and how to use them, you will find yourself thinking more and more about subject matter. Those new to art often choose subjects based on what they admire in others' work. This is okay for awhile, but it will eventually become boring—to you and to your viewers. If you expect to be in art for the long haul, it is important to deal with what truly engages you. You must confront the problem of coming up with ideas.

It may be comforting to know at the outset that there are no new ideas. Everything has been done, and much of it overdone. The only fresh and original thing you will ever have to offer is your own personality, your own way of seeing things truthfully. The more you enlist and express your own true feelings and attitudes, the more original and cliché free your work will be. Simple and straightforward as this may sound, it is something that eludes many artists. It may, in fact, be the chief reason that artists sometimes fail to gain the recognition their excellence of technique seems to deserve.

Consider florals. Has there ever been a subject more thoroughly done? Can there be any freshness at all squeezed out of yet another floral? Sure there

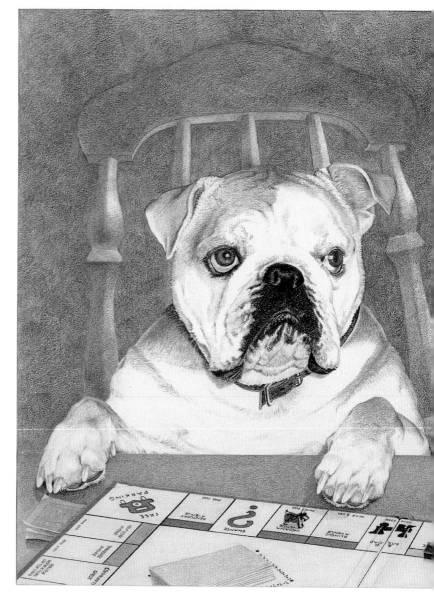

WATCHDOG
Colored pencil on Strathmore Bristol Board, $17^1/_2 \times 24^1/_2$" (44 × 62 cm). Private collection.

When using animal imagery I am wary of any temptation to become too anthropomorphic—always a very fast slide into the saccharine. I didn't want to merely render a vignetted head-and-shoulders likeness of a friend's family pet. Instead I wanted to suggest this dog's personality and some of the lighthearted mood of her family environment.

Bertha was smart, but had never (as far as I know) actively participated in a game of Monopoly. But for me including the gameboard suggests fun and fondly remembered family times together, and this animal was surely a part of this. In Bertha's case, her demureness and femininity often took people by surprise. For this reason, composing her with a floral reference seemed to make a nice counterpoint to a face that looks pugnacious but which in truth conceals a tender character.

can be—if the artist can express a fresh attitude about it. Maybe a luxurious—and slightly jaded—abundance, hinting at too much of the "good life"; or a bristling, edgy adolescent of a bouquet.

Good starting questions to ask yourself are these: Are you in art to reveal yourself or to conceal yourself? Are you a classicist with a high regard for intellectual order, or are you a romantic with a palpable, physical sense of emotion? Is humor or irony important to you? Do you believe that the only true path is through social commentary, or are you more interested in the introspective opportunities in pure ornament?

As you think about such issues as these, and back up your thinking with solid technique, your work will almost surely begin to show a maturity and an

authority. But perhaps even more important, your work at art will become so engaging to you that it will claim a high priority in your daily existence, and you will want to stay with it forever.

FINDING INSPIRATION

For all of us on any given day, it is almost a miracle that we pick our way through the landmines of duty, responsibility, family needs, entertainment, fatigue, and into our art workspace. When we do make the time, how can we arrive there fully inspired?

It is important to know and to remember that inspiration is not the wild-eyed, struck-dumb kind of seizure that the media and pop culture keep telling us it is. Inspiration is merely a heightened feeling of power and energy. It is not a constant or magical state, but one that comes and goes as a by-product of an active and open mind. Do not wait for inspiration. It will come as you begin to work, even when you feel utterly empty of ideas. So if it's inspiration you want, start working.

Other things, too, can sometimes get the process going. I keep a pile of small paper fragments—saved notes and visual ideas scribbled at odd moments. Even though I may not choose anything from it, just sifting through this debris of past excitements sometimes kindles a new excitement. Looking at the artwork of others, and at artists' biographies can also be motivating. It builds pride to read about your fellow artist kin, and to feel a part of this lineage. Excellence of all kinds—writing, music, theater—can inspire. It is the inspiration behind excellence that is recognized. And it is contagious.

Tip

Artists of every kind develop ways of invoking inspiration. One way of doing this is with musical association. During times when you are drawing well and feeling the flush of heightened awareness and focus, play music—favorite instrumentals that themselves always seem to you exciting. Repeat the linking of music with your times of inspiration as much as you can. Soon, when you are starting work but have only limited energy and enthusiasm for it, turning on your music will bring back your feelings of optimism and inspiration. Try it.

Working from Life and from Photography

Art galleries now seem to offer every imaginable kind of art. Today's culture—diverse, plastic, and constantly in transition—churns with imagery as it communicates our social complexity. Never before has art worn so many faces.

Whether we find our subjects in real life or in photographic references is no longer much of an issue. What we must concern ourselves with, instead of sidetracks like this, is our personal ideas and concepts, and how best to present them. Some artists work entirely from imagination, from their own intellectual fragments and impressions. Others work from the real world or from photographs of it. These are personal choices, and they don't much matter really. For art resides potentially in our minds and hearts, not in the techniques or equipment with which we express it.

Most of us who gravitate toward this medium like to depict a visual reality, or at least a strong impression of reality. A pencil point offers us an unprecedented control and versatility toward this end. And so sometimes do photographs. But our problem is not whether we stick to life or use photography; it is rather how to best blend the two. Here are a few possible scenarios for doing this with familiar subjects.

1. *Still life.* Of all the genres, this one may seem the most naturally suited to working from life. We are dealing with objects that do not move, and neither do artificial light sources on them.

2. *Landscape.* There are various choices here. We can set up in the field and work entirely from life. We can begin in the field, photograph it all,

Here is a photograph with multiple distortions. The first problem in this too-close view would be the ballooning of the bananas. Among other problems are the little antique camera's severely tilted vertical lines, and the swiftness with which the patterned fabric appears to diminish in size.

then finish in the studio. Or we can simply photograph a setting, make notes regarding colors and our feelings about it all, then do the whole drawing in the studio. All three methods are reliable. And even those who actually draw while on location will likely make some color adjustments back in the studio so everything reads right under artificial lighting.

3. *Portrait.* Working in colored pencil is usually a slower process than that of pastel or watercolor. Models can seldom pose long enough, and photography is a great help. Some portrait artists begin with a face-to-face session, while others rely on a second, finishing session.

PHOTOGRAPHY AS A REFERENCE TOOL

The tradition of using photography as an artistic tool goes back to photography's beginnings in the 1800s, and earlier use of the camera obscura is historical fact. Indeed a great deal of our modern composition owes a debt to the laissez faire kind of cropping so readily found in photographs.

We have learned to accept the distorted and monocular photographic view of the world simply because we know it to be a photograph—and therefore probably true to life. The trouble with basing a drawing entirely on a photograph is that the end result is no longer a photograph, and it is no longer believable for the same reasons a photograph is. A photograph is seen in only two dimensions. What we see with our eyes, we see in three. Illusions of three dimensions on a drawn surface and in a photograph happen in different ways.

There are methods, however, for overcoming some of a photograph's characteristic distortions when transferring information from it to a drawing. What they require is a combination of freehand drawing experience and some knowledge of how space is created and form modeled in art (as discussed in Chapter 2). Here are some specific photographic problems to know about:

1. *Relative size distortions.* If you are drawing a still life or part of a room interior from a photograph, be ready to resize elements nearest the camera that may loom unnaturally large. Things just a little farther back may likewise appear too small. One-eyed camera lenses also compress or flatten the space between things. Be sure your initial layout allows enough space for objects to occupy logically.

SARA
18¼ × 14½" (46 × 37 cm), black-and-white photographic print
by Edwin Borgeson. Private collection.

Pictures like this tempt us to try drawing directly
from them. The problem is that the doll's face is only
photographically modeled. If traced, the drawing would
not contain enough modeling with light and shade to
reveal its three-dimensional form; its strength as a
photograph would vanish as a drawing.

2. *Lack of subjectivity.* No lens sees in the subjective,
 psychological way we do. The lens neither
 emphasizes nor de-emphasizes—as we do when
 we draw. An example of this can be seen in a
 portrait copied exactly from a photograph, where
 the eyes appear too small. (We accept the eyes in
 a photo because it is a photo.) Artists drawing
 freehand from life almost always enlarge the eyes,
 for eyes and the flesh around them are important
 to us as clues to character.

3. *Photographic modeling of form.* The light and shade
 in a photo are not the same as the light and shade
 used in art for modeling form and creating volume.
 Form that is copied or traced without adding
 and adjusting this light and shade will appear flat
 and two-dimensional.

4. *Exaggerated highlights.* There is a reduction and a
 generalizing of the value range in photography.
 Photographic highlights occupy more space and

contain less subtlety of gradation than those we
see in life. Sometimes whole areas are bleached
out. When we arrive at such areas in a reference
we must be prepared to reveal the form, even if
it is not in the photo, and restate the highlight
more moderately.

5. *Generalized colors.* The range of color in
 photographs is very narrow. Colors are frequently
 too vivid and too unmodulated, causing them to
 appear too generalized, too textureless, and too flat.

6. *Converging verticals.* Most handheld cameras do
 not correct for the natural vertical convergences
 of doorways, windows, and buildings as our
 brains do. If not corrected in a drawing, these
 converging verticals will look false and draw
 attention to the drawing's photo source.

Photographs have become very compelling sources
of information to us. We believe what they show
unless we know or suspect that they have been
manipulated. To use them as reference tools, we
must always be ready to sort through their visual
information, and be prepared to edit and adjust it.
During the 1960s, photorealism was seriously
explored as an art form. Artists working in this
idiom purposely did not change the photo images
when translating them to painting because they
wished to keep their sources fully in front of the
viewer. But today photography is essentially used as
a reference tool and drawing aid, and exact photo
quality in art is not celebrated.

TRACING AS AN AID TO DRAWING
Part of the colored pencil medium's popularity is
its ability to be used vertically, as on a wall, without
dripping or running. This makes it easy to use colored
pencils for tracing from an opaque print or slide
projector. And as a drawing aid, this is certainly a
bonus. But tracing can be overused, and can in fact
lead to a look of soulessness, due to complete
abandonment of freehand drawing. It has always
seemed to me that freehand drawing is a pipeline
from the soul.

An artist who traces everything is perfecting the
copyist's craft rather than the techniques of fine art.
For the route of slavish tracing subverts experiencing
visual information firsthand, enlisting all one's
senses, making selective decisions, and expressing
personal feelings. And work that is entirely traced,
without artistic processing, will usually lack the
essence of individuality. There is a place for tracery
as a minor aid, but there are dangers in relying on it
too heavily.

Building Your Own Techniques

Because colored pencil can become so exquisitely responsive in an artist's hand, it has yielded a wealth of techniques and processes, forming a unique repertoire. There are now so many of these techniques that it seems very limiting to single out a few and claim them superior to all others. The reality is, the more you draw with colored pencils, the more you will discover your own best methods.

TECHNIQUE AND TIME

There is a wise admonition in art that we should seek out only enough technique to express the effects we want—and no more. The colored pencil medium, with its unrivaled potential for precise high realism, and with its attraction to many artists for exactly this reason, has spawned a few techniques that are extremely time-intensive. But worse, these techniques split up drawing and color application into small and separate tasks. An accepted fact of art is, and has always been, that working laboriously, element by element, rather than on a whole piece alla prima, is destructive to cohesion and unity. Working this way, vitality and spontaneity are sacrificed for the process.

Developing our abilities and judgment as artists requires that we begin, work at, and finish many pieces. This kind of continuum allows us to experience and solve a variety of problems arising at different stages in a variety of drawings. If in order to achieve a time-intensive high realism we attempt only two or three drawings a year, our chances of fully experiencing the necessary learning process are very slim.

You will reach your goals in this medium more easily and naturally—and much more swiftly—if you begin by mastering the techniques of basic layering and juxtaposing, color lifting, and line impressing. Avoid esoteric processes that monopolize all your precious art time. So many other issues in art need attending to that we must try not to be seduced by what is too often meaningless form.

COLORED PENCIL IS A MEDIUM OF TEXTURE

There are two great paths in this medium—textured and nontextured. You will want to explore both, for they are very different from each other, and they appeal to different temperaments.

The first of these paths, that of texture, is recognizable by its granular appearance and softened color. These characteristic effects are generated by using variable pencil pressures and lead sharpnesses over surfaces ranging from a medium to a fine grain.

A sharp pencil yields a fine or minimal texture. A dull or flat pencil results in coarser texture.

The other great path of colored pencil work is characterized by an absence of texture—not just a lessening of texture, but an absolute absence of it. And it is here that this medium most resembles painting. Because there are none of the white flecks of paper that occur in the texture path, the colors achieved are more bold and saturated. This kind of drawing is done by first using variable pencil pressure to establish color mixes, then by following up with very heavy pencil pressure to completely flatten the paper's grain.

While this nontextured path has more color boldness, it lacks much of the subtlety possible with variable pencil pressure. Any texture wanted, in fact, would have to be specifically hand drawn. Color boldness at the cost of subtlety might be a drawback. Or it might not. This is where the temperament of the artist comes into play.

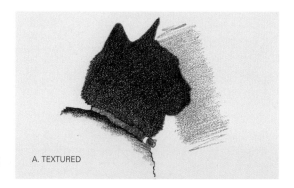

A. TEXTURED

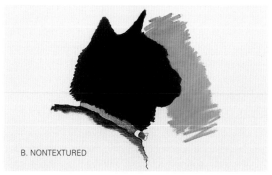

B. NONTEXTURED

Although both cats are tonal drawings they look very different, and their differences represent two approaches. The color of the top cat (A) was applied with a rounded point to reveal the texture of the paper's grain. Variable pencil pressure and points are used. Colors are softened. The bottom cat (B) reveals no texture, as heavy pencil pressure obliterates the paper's grain. Colors look more intense.

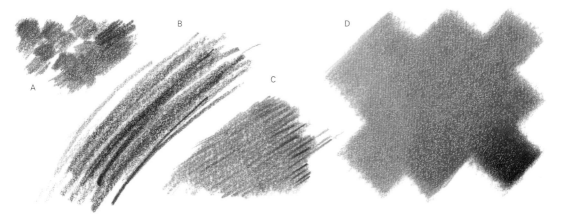

Different strokes and point sharpnesses can be seen here. Tonal application in the textured mode, used in realistic work, will start off like this (A). Strokes are short, averaging about 1/4 inch. The point is maintained sharp or semisharp, and everything merges and blends.

Long strokes—even those meant to merge—are seldom used except for gestural, loose styles. This application (B) has less control and appears more spontaneous, but tends to be a very poor vehicle for color mixing.

This sample (C) is a combination of tonal application (red) and linear (purple) hatches. The red was applied

to maximize texture; it could have been applied to minimize texture by using a sharper pencil.

In this finely textured sample (D) six colored pencil colors were applied tonally in one layer with very sharp points. This minimizes grain. The patch began with short strokes merging together (A), but with different colors. Sharp points fill the valleys of the paper, reducing the white flecks that mix optically with the pencil color, and are used when vividness, clarity, or dark values are needed. One advantage of working in the textural path is that there is a minimum of waxy buildup that accompanies heavy pressure or burnishing techniques.

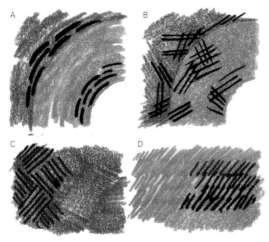

Although tonal application plays down its linear origins, stroke direction and placement do influence the final tonal appearance. In the first example (A) stroking follows the form. For these examples I included some ink strokes to indicate placement and directions of pencil strokes. Mimicking the form with strokes exaggerates form and can be an unwanted effect. To avoid this, stroke in various directions as in the next example (B).

In the lower example (C) strokes are "bundled" and in the last example (D) strokes are placed in rows that look like "ribbing." These two ways of stroking are by no means the only alternative ways to apply color, but they are fast ways of delivering solid areas of colors that require little refining.

This swatch of color, 902 ultramarine, was first applied with a flattish point that generated a lot of open white flecks. This is a fast way of delivering color, but its coarse grain needs refining. This was done on the upper half with contrasting colors and sharp points.

The refined area (top) is still a single layer because the additional colors were only used on the white flecks—not on the mass blue color. Not only is this a fast technique, but it also produces a complex final color.

LAYERING

Most work done in this medium is done with layering—with building solid tonal areas, or tonal areas plus line. As you do this, try to use no more than two to four layers. More than this risks overworked passages, too much wax build-up, and far too much time-intensiveness. There are artists who report using as many as twenty-five layers, but any success they achieve is probably in spite of this, not because of it.

But counting layers is really a false notion. As you gain experience with this medium, you will know that you are not applying pencil layers as if they are multiple sheets of colored cellophane. What you are actually doing is applying pencil pigment in bits and pieces, with spots or areas of layering and partial layering. When you add to this some juxtaposed passages, and perhaps some hatching and cross-hatching with lines, the whole subject of how many layers becomes of no consequence.

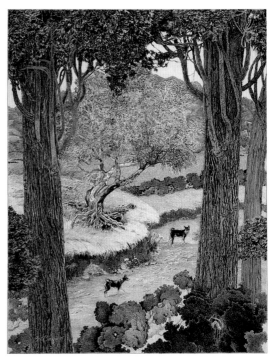

TRAVELERS
Colored pencil on Rising Museum Board,
27 × 21" (69 × 53 cm). Collection of the artist.

TRAVELERS (DETAIL)
Colored pencil on
Rising Museum Board,
27 × 21" (69 × 53 cm).
Collection of the artist.

I now work in one or two layers of juxtaposed colors, with just enough overlapping to make a seamless transition. In *Travelers*, the trees appear one color, but in this detail you can see the various side-by-side colors that make up the reddish brown. In the green vegetation two layers were used but with frequent changes in the choices.

Demonstration: Color Lifting Techniques

These ingenious techniques are a joy to use and from the start have been embraced by artists in this medium as a basis on which to build. Not only does color lifting allow us to erase and adjust color—even in large areas—but it offers us textural effects impossible to achieve any other way. These methods also enable us to draw negatively into color that has already been applied—as a preplanned effect or as an afterthought. To accomplish them we use frisket film with various blunt and pointed burnishers or, in tougher cases, tacky tapes, such as masking tape.

The materials necessary for lifting color are simple. You will need a few different tacky surfaces, such as masking tape—really the best for lifting tenacious color—and frisket film.

You will also need a broad nib burnishing tool (the middle one here is a bone version; the one at right is a clay modeling tool) and a ball-tipped burnisher. This last tool is the best I've found for lifting drawn strokes, whether over tape or film, and it has both a small and large ball.

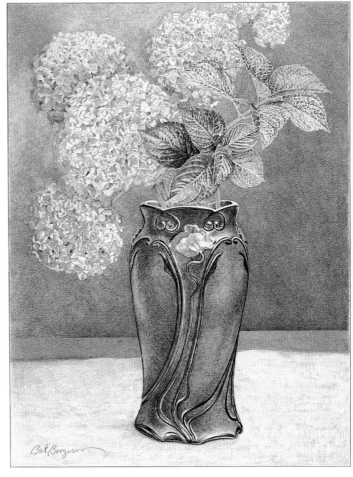

ROSEVILLE BOUQUET
(FIRST VERSION)
Colored pencil on Rising Museum Board,
17 × 13" (43 × 33 cm).
Collection of the artist.

I have kept this failed drawing around because I liked some of it—the yellow tablecloth drawn with lifting techniques, and the vase itself, patterned after a Roseville Pottery umbrella stand. But the hydrangeas and their foliage—great in the garden—seem strangely dowdy singled out and placed on the two-dimensional surface of this drawing. Originally, I positioned the foliage in front to mitigate the flowers' bulbousness, but the leaves now appear too insubstantial for such prominence.

What this piece needs are some radical changes using color lifting techniques. I want to remove the left center hydrangea and replace it with two poppies (similar to the one on the vase). A red-orange color would be more dramatic than the present weak pink, and would stand up to the strength of the vase better.

I'll also try lifting some blue negative space on the opposite side, and add a third poppy there. I'll also overlap some of the foliage with the flower additions to downplay the foliage.

Step 1. Because lifts needed here are extensive and gross, I use masking tape—my strongest tacky tape—for this initial step. This tape's tackiness is so strong, I can just float it into position without patting it down. Then, using a burnisher with a medium-wide nib, I lightly smooth down the tape. As the tape is slightly transparent, I can roughly see the area I want to lift. I don't worry about lifting some of the surrounding color; I'll simply restate it later. After pressing the tape down, I lift it gingerly, being careful not to tear the paper fibers.

About burnishing pressure: Although the name of this technique makes it sound as if a lot of pressure is needed, the more pressure you exert (whether with tape or frisket film) the less color will be lifted. The object is to make good contact only. If not enough color comes off, just repeat the process with a fresh piece of tape or film.

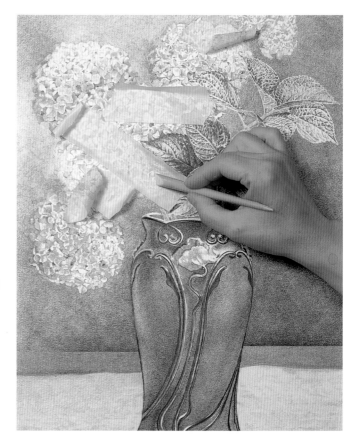

Step. 2. Here is the drawing with the color lifts visible. Because my new poppies are going to be an analogous color to that of the removed hydrangea, and darker, I don't need to remove all the pink; it can just be included into future red mixes. If I should find too much pink showing in a future light area, I'll remove more.

The blue is another matter. Because it is not analogous to red-orange, I must remove as much of it as I can so it won't overly drab the future color.

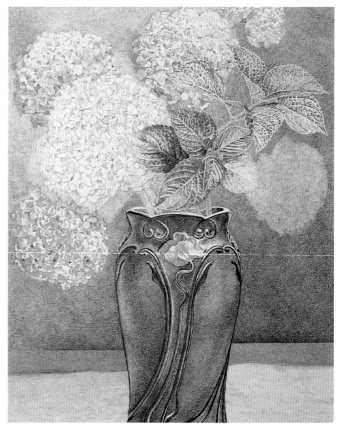

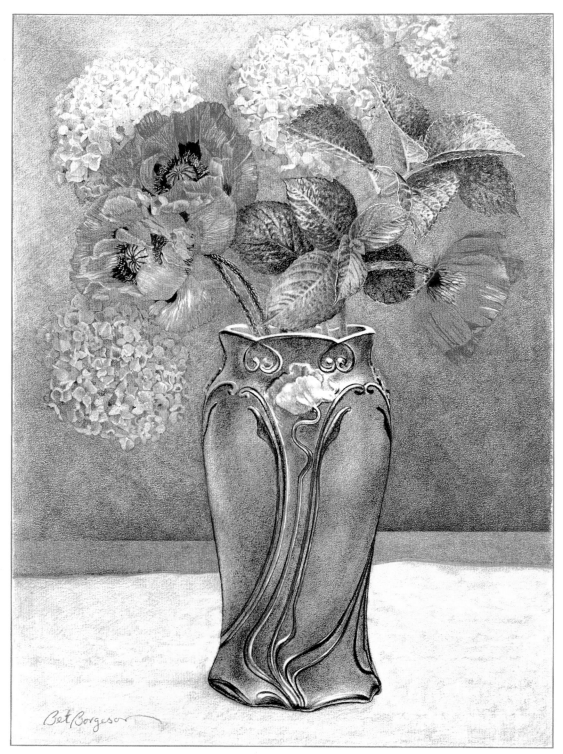

Bet Borgeson

ROSEVILLE BOUQUET (SECOND VERSION)
Colored pencil on
Rising Museum Board,
17 × 13" (43 × 33 cm).
Collection of the artist.

The color lifting techniques allowed me to take out one hydrangea, replace it with two poppies, then add a new poppy where before there was only negative space. Doing this strengthened the composition, and relieved the monotony of the pale pink hydrangeas. Moreover, lifting away some of the green leaves enabled me to overlap poppy heads and stems, helping to deemphasize these leaves. Compare this piece with its original version on page 49.

Demonstration:
Impressed Line Technique

White pencil alone cannot satisfactorily render white or light-valued lines on white paper. So we use color lifting techniques or impressed line technique. The difference between these two is that impressed lines are more emphatic than lifted lines. Materials needed for impressing lines are a graphite pencil, a piece of tracing paper that can be seen through easily, and a drawing paper surface that is somewhat soft or is cushioned with an additional sheet under it.

In this four-step method, an impressing of white line is used to develop an ambient or all-over texture in a monochromatic drawing that features texture.

Step 1. I begin by defining the two positive shapes of the cats, using Prismacolor 931 dark purple and a rounded pencil point. The negative space, already looking streamlike between the adjacent forms, is left blank.

Step 2. To impress a linear texture into the drawing's negative space, I first cover the area with a small sheet of tracing paper, tacked in place with masking tape. With an HB drawing pencil and fairly firm pressure, I draw the desired lines on the tracing paper, telegraphing an impression into the soft drawing sheet. (A hard thin drawing paper is not as receptive to this technique.) This step, which sometimes feels more craftlike than artlike, may cause us to draw less sensitively. When using tracing paper to impress lines, we still must draw with varying pressures.

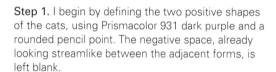

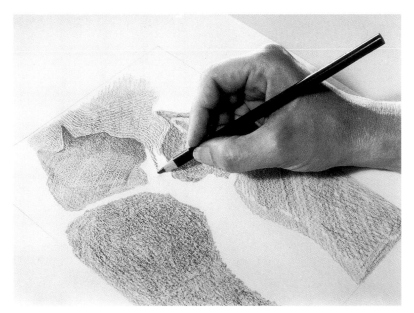

Step 3. Removing the tracing paper, I tonally apply a single light layer of the 931 dark purple, this time with a well sharpened pencil, over all the negative space. Each time my pencil runs across an impression, a white line appears.

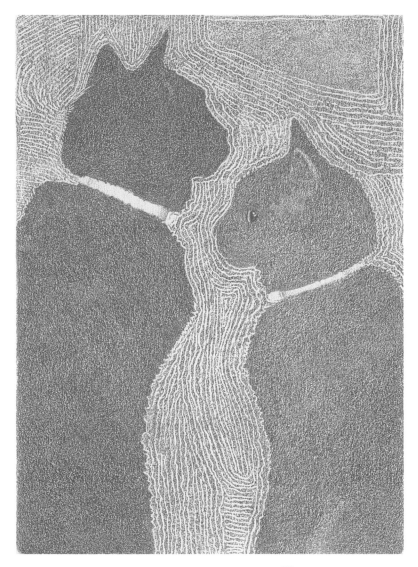

COMPANIONS NO. 2
Colored pencil on
Strathmore Bristol Board,
6 7/8 × 9 1/4" (17 × 23 cm).
Private collection.

Step 4. With the negative space fully developed, the cats are further refined with 931 dark purple. The pencil point is kept sharp. Notice that there are now four distinct textures in this simple small piece: a combination of paper grain and drawn texture in the negative space, two different textures in the two cats, and still a fourth texture in the cat's single eye.

A Working Procedure

Process in art is a concept that is often misunderstood and undervalued, yet it is an essential part of each artist's creativity. More than being a mere set of routines, or a conduit between idea and technique, it is often the modifier of idea as it meets with technique, or of technique confronted with idea. All this and more are the real meanings of artistic process.

In discussing layering I said that some artists report using as many as twenty-five layers, and that any success achieved was probably in spite of and not because of this. What may be happening in a case like this, is that the laborious application of many layers so slows the work that ample time is provided for reflecting on other problems and issues of the drawing. For some, such an eccentric process might be productive and good—with many layers of color simply slowing things down to allow thinking time.

Your own working procedure will become extremely important to you. It can promote a wonderful work flow or it can impede one. Here is a five-step method you might consider starting with. Although, as time goes on, you may change or amend this to something more perfectly fitted to your needs, it will help you think in color rather than in black-and-white terms. It will also help you confront the background or negative space from the beginning rather than later when it is possibly too late, and it will speed your work by minimizing time spent reworking poorly thought out passages.

CONTENT

Take the time you need to figure out what your idea, theme, or attitude is about the subject you want to draw. Be able to state this in a single sentence. You may wonder if your subject is so simple that it might hardly warrant thinking about. Emphatically not true! Everything has a meaning that, upon reflection, will tell you what attracted you to it, what made you want it for a subject.

THUMBNAILS

For some, preliminary planning is the hardest step of all. It can seem to interrupt the excitement of beginning a new piece. And if its only purpose were to save time, its value in the long run might indeed be questionable. But there is more to it than saving time. The process of making quick and rough little thumbnail drawings will have you thinking in color

After making a few rough thumbnails in graphite of my drawing idea, I select one that has an arrangement of elements that seems to work visually.

Laying a piece of tracing paper over the thumbnail, I quickly try out color ideas, using the thumbnail underneath as a pattern. I can try as many versions as I want by moving the tracing paper to a clean area.

A first payoff of taking the time to do this, is a color scheme I can have confidence in. But there is an additional benefit. For artists who have trouble deciding what to do with a background after having spent a lot of time on other elements, a thumbnail rough and color schemes may help to see the whole composition rather than just the subject. This early stage is the best time to confront decisions about background concerns.

immediately, seeing your whole composition in miniature, and confronting issues of the background.

Here is a good way to do it. On a piece of scratch paper, draw some frames of reference—rectangles of varied proportions, squares, and even some diptychs if wanted. Then using a no-nonsense graphite line (one not repetitive, sensitive, searching, or elegant) lay out a few compositions in different ways in the frames. Keep it simple, with no value changes. All you want is to position elements, not render them. This step will help you decide if your idea can really be visually expressed. If you find an arrangement you like, place a sheet of tracing paper over it and work up some appropriate color. Use your thumbnail only as a pattern, over which you can try any color ideas you may have for major and minor elements as well as for the background. If you don't like what's happening, simply move the tracing paper to a clean area and try again. Because your pattern stays put and doesn't have to be redrawn each time, this is a speedy process. And testing colors at this early stage may prompt a change in your composition, or even in the original concept. It is a fast and idea-building way of working.

LAYING OUT THE DRAWING

When you think you have worked out a composition and some of the colors, you will need to lay out guidelines onto your drawing surface. I use graphite pencil for this, very lightly so it does not have to be erased later. Instead of doing this directly onto paper, I like to first work out a full-sized line drawing on tracing paper, then trace this on a light table onto a clean drawing board or paper. (A daylit window can substitute for a light table or light box.) Even though I usually draw on two-ply Rising Museum Board, I can still make out the simple lines of my tracing paper image.

WORKING ON ADJACENT AREAS

This is the moment when just about every artist—experienced or less so—hesitates, sorting out where to begin and what colors to start with. Each of us approaches this step in his or her own way, depending on our personalities and the needs of the piece. There is no winning formula, no one-way-suits-all. One suggestion—reliable and time-tested in many mediums—is to work on adjoining areas. For example, to establish the flesh of a cheek in a portrait, first lay in some colors in the area next to it—the hair, the negative space, and so on. The

reason for this is that if you make your color decisions for the cheek based on the adjoining white of the paper, you will probably be making a color mix that depends on a white environment. And later, when you apply color in that white area, the flesh will no longer look quite right.

Try to get in the habit of moving around the drawing as you work, laying in colors for adjoining or adjacent areas of major elements. Working alla prima in this way will help you avoid the appliquéd or pasted-on appearance that can result from rendering one element at a time. There is an exception: If you are developing a unique and interesting texture as you draw, you may have to stay in an area longer, for sometimes the same uniqueness cannot be readily summoned again in a later work period.

Choices of pencil colors, meanwhile, must be determined by the needs of your drawing and your own process. Some artists select colors to immediately reinforce attitude or theme, others select with multiple layers in mind. Still others shoot mainly for local color, then add modulation or "seasoning" to it. Again, there is no truly right or wrong way of choosing colors.

FINISHING THE DRAWING

Deciding when a drawing is finished, or how to finish it, can be an elusive problem. Surprisingly, work of a simple quality, or that which is generally unstructured, can be especially difficult in this regard. Fuller discussion of this final step will show up a little later in this chapter.

Tips

Sharpen up and slow down! When you need color intensity, sharpen your pencils frequently to minimize the paper's white flecks. And slow down, except in your most broadly drawn areas. (If slowing down is too frustrating for you, and doesn't get better with time, you may want to explore adding a broad color tool such as Art Stix or pastel, or an aqueous medium such as watercolor to your colored pencil process.) It is also a good idea to work first in areas of your drawing that you perceive as the most problematic. Confronting these early can often make an entire drawing flow more smoothly and quickly.

Appraising Work in Progress

Let's think of technique as the skin of art, and critical judgment as the skeleton. Both work together, and both can be learned, shaped, and honed.

Critical judgment is based on objectivity. When you become serious about art, you cease to be a civilian. You will have drawn a special kind of duty, part of which is to see artwork with clarity, and with an almost passionate detachment. You must look for relationships and try to understand the significance of latent meanings. You will want to know *why* a particular thing has a certain effect, exactly *where* this happens, and *how* it is accomplished. An active participant or expert in any other field is expected to know about things in his or her area of expertise that those outside it hardly suspect exist. Why should this not be true in art?

THE DREADED PLATEAU

An ability to accurately appraise work in progress is instrumental in experiencing a steady artistic growth. It will help you see new opportunities in your work. But a still greater payoff is that later, farther down the road, it may become the most direct way off a frustrating plateau—that barren and muddy region where growth so often becomes mired.

With colored pencils, as with any art medium, it is a rather straightforward process to become competent. Going beyond this will depend on your ability to constantly scan and correct your artwork's progress and direction. Here are a few suggestions for refining your appraisal skills:

First of all start acquiring a meaningful art vocabulary with which to carry on internal conversations about your work. This vocabulary comes from immersing yourself in art's fundamental concepts. Secondly, try seeing work in its most basic components. I use seven categories for this.

- basic idea
- composition
- draftsmanship
- color
- textural character
- mood
- unity

As you sift through these concerns, try to clearly describe how each is operating in the piece at hand. Using your art vocabulary and knowledge of fundamentals, ask yourself if each category is working as you intended—and if not, why not? *Be specific.*

GOODNESS

Through years of working with students, critiquing work, looking at exhibitions, and living a life in art, I have come to believe that some artwork that is otherwise technically competent often fails for lack of passion and rashness. We need to be sensitive.

The title of this work in progress is *Flowers and Make-Believe*. I have appraised it by referring to the seven basic components discussed.

- *Basic idea.* Good. Flowers with a paper doily to express a wedding bouquetlike element suggests the make-believe quality of weddings.
- *Composition.* Balance, symmetry are appropriate.
- *Draftsmanship.* Good.
- *Color.* A problem! This was conceived as a high key (light) drawing to reinforce a dreamy state. But it's too light. A fix might be more variety of value, and lost-and-found edges instead of high-key values.
- *Textural character.* Needs more variety of grain.
- *Mood.* Good. Must take care not to lose it when piece is darkened.
- *Unity.* Has it now. Don't lose it with changes.

But like a genetic trait that is often in the company of another trait, sensitivity is often linked to carefulness. And this trait can lead to stagnation.

To travel to the realm of goodness in art—that playground between conscienciousness and rashness—we must be willing to depart from familiar safe places. And, because goodness lives next to ridiculousness, it takes quite a measure of courage and maybe also a bit of naïveté to share such close quaters.

Another aspect of true goodness is its lack of perfection. Superior art ironically often has a scratchy or unsettled quality about it. It is not exemplary in a conventional way, but instead contains undercurrents of vulnerability. This imperfectness of expression, executed powerfully, may in fact be at the crux of its attention-getting, and holding, greatness. Perhaps a surplus of perfection would lessen its humanity.

This work in progress, *Long Game*, is more complex and would be difficult to appraise accurately without some kind of mental check list.

- *Basic idea*. Good. We all know this game can last for hours, and we might be forced to munch on goodies to see us through it.

- *Composition*. A problem. Don't know where to look first. The dark cookies were meant to be steadying anchors and lead the eye through the composition. But they are not strong enough to compete with the other elements. The tablecloth and some peripheral elements should be deemphasized.

- *Draftsmanship*. Big problem here. The gameboard is out of square and has a slight fan shape. Surprisingly, this can still be fixed, and doing so

will also help correct the busy composition. Although it's too late to change the board itself, lifting the tablecloth's nearly opposite color and changing it to blue (though slightly different than the blue gameboard edge) will downplay the out-of-square problem. It should also help calm the environment so we can see things better.

- *Color*. Too light! Looks like an underpainting. Must sharpen up and slow down, and when I mean dark, deliver dark!

- *Textural character*. This will improve if I correct the value lightnesses because I will need to sharpen up to achieve convincing darks.

- *Mood*. Good.

- *Unity*. A bit scattered. The above changes should improve this.

Knowing When You're Finished

Finishing a drawing is really the fifth and final step in the basic working procedure outlined earlier. For many artists this turns out to be an elusive thing, and one worth amplification.

A writer of mysteries must know at the beginning what clues mean what, and how it will all come out. As visual artists we too will know when our drawing is finished if in the beginning we understand our purpose, and its major and minor tasks.

For the end result is not really a separate thing from the beginning, but grows out of it as a logical result. Like a builder working from a set of plans, an artist needs to have an agenda and move every component forward toward communicating it.

Oddly, a very simple drawing, or one that is intentionally unstructured, loose, or boldly gestural can be harder to bring to conclusion than a complex, highly realistic drawing. Full realistic rendering contains its own logical and credible ending by posing and answering the question: "Have I made all this as real as I can?" A less finished-appearing drawing, meanwhile, one designed to look spontaneous and to rely for its effect on emotive suggestion rather than high realism, may be more difficult to conclude due to doubts about its authority or credibility. To work successfully in this format an artist must juggle tasks more subtle and mercurial than those of pure realism.

Another factor that can keep a drawing stalled just short of the finish involves personal confrontation. This is a situation in which so long as a drawing stays unfinished, the jury remains out, so to speak. When the work becomes officially finished, it (and we too) must expect to endure some kind of judgment. Unsettling as this can be, it is simply a form of exposure all artists must grapple with and come to terms with. It is a shared burden among us.

A METHOD FOR FINISHING

There are some real steps we can take to bring a piece to conclusion. Because working in a concentrated manner over time seems to dull objectivity, it is essential to reclaim as much of this as possible. As a start, change the environment of your piece.

When nearing the end of a project we are sometimes tempted to begin dabbling and noodling here and there. It is better to remove the drawing instead to another room or to another part of your workspace. The piece doesn't have to be at eye level. It can lie flat on the floor or propped up against a wall. Get a notepad and pencil and have a good look at your work.

There are two overall areas of concern. They are content and form, and you'll need to appraise both. Now is the time to ask yourself if your central idea or attitude comes through. Can you see the devices you have used to do this? Do you need to tone them down or beef them up? As you ponder this, write down what you'll need to do in this area. Give each adjustment a number.

Next, appraise the technical work. Are there any areas that vaguely bother or disappoint you? Are the dark values completely stated? Are there elements that jar or pull focus too much for reasons of hue, value, intensity, and so on? Relying on your technical vocabulary and the appraisal skills earlier discussed, try to be very specific about what is going on in any doubtful areas. Again, write it down.

When you return the piece to your workspace, make the corrections you have noted, one by one. As you are satisfied with each adjustment, cross it off your list. This brings a note of finality. Using this somewhat structured routine may help as a format for final revisions, and also as a way of building your confidence about finishing.

Is this piece finished or not? Time for a hard look—an end-appraisal.

The content is good: The gnarled quality combined with the spread and girth of the trees reinforce the idea that these two are long-time survivors. Large old trees have been gathering places in many times, and have borne witness to many things. My working title is *Storytellers*. Overall the composition is good. Technically, however, there are some small but critical changes needed. Any rule against using "twosies" is one that I think can be ignored. Why must three elements be better than two? There are endless possibilities in the nature of relationships between any combination of things—including inanimate things.

But there is a scattered kind of quality here that keeps the drawing from being dramatic. It is hard for a viewer to know where to look first. I need to emphasize tree trunks, branches, and dappled shadows, and to better define cast shadows on the meadow floor. To do this I must increase value contrast among these principal features.

Some small changes: I want to include lichen on the left tree. Because leaves of the small tree at center right seem to be avoiding the big tree's leaves, I'll need to combine their leaves better. As all the major foliage seems to exist on only one plane, I'll need to add some vivid color so some of the leaves advance, then darken others to help some recede.

STORYTELLERS
Colored pencil on Rising Museum Board,
23 × 16¹/₂" (58 × 42 cm). Collection of the artist.

To add more drama, allowing the trees and the play of shadows to really show well, I needed to increase value contrast. I did this with sharp points—always refining away white paper flecks. I darkened the cast shadows on the meadow floor, using the original colors, but with more determination. This more clearly stated the thatchiness of the dry grass.

Next I darkened and unified the blue shade on the trunks and restated it farther up the large branches. I further defined the trunks and branches by increasing value contrasts. For impact, I added intense colors to warm areas on the trunks. I restated trunk edges, always with a sharp point, to separate them from the environment. Where necessary I also darkened or lightened the environment where it joins the tree contours. To bring some foliage forward I used a vivid blue-green pencil; to push other foliage back, I darkened with indigo blue and sepia.

After increasing the lichen on both trunks, and adding leaves to the distant tree, the changes on my list were all crossed off. Overall the tasks needed to finish this drawing boiled down to these: sharpen pencil points, refine away white paper flecks, and increase value contrasts among prominent elements for the necessary emphasis and deemphasis of drama.

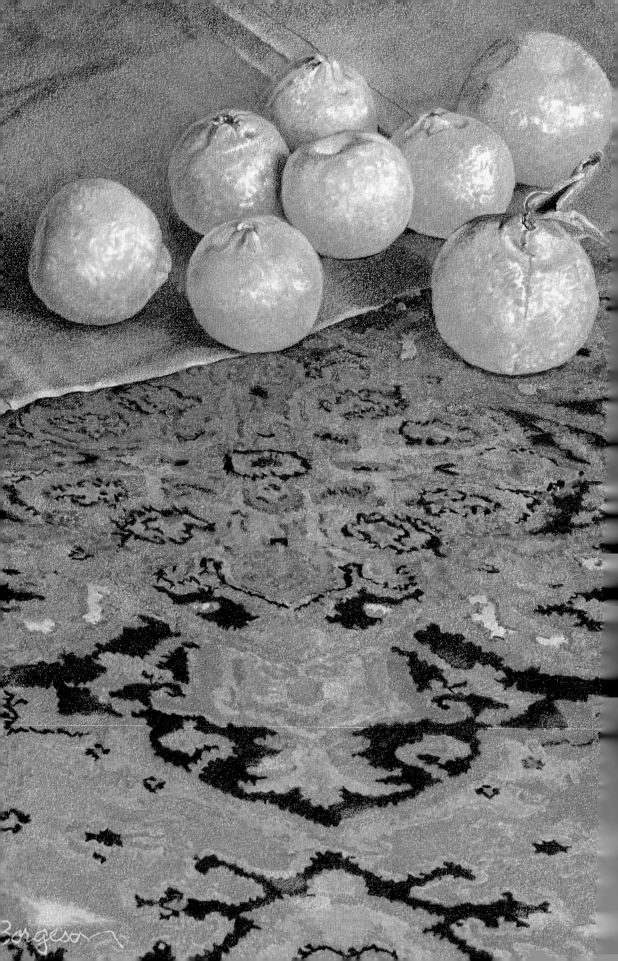

Still Life and Floral

Your development as a serious artist can be advanced and sustained by working with still lifes. In the beginning, still lifes provide a low-stress way of drawing and learning. You can work in privacy, and at an unhurried pace. You need not concern yourself with such things as weather, or finding and scheduling life drawing or portrait models. Working with still lifes will give you control over these and many other variables that often bedevil newcomers to art.

Even with experience in art, working with still lifes, regardless of what other areas you work in, will help you review your understanding of many art principles. Its intimate scope and easy familiarity can also help to replenish flagging confidence or personal perspective.

In this chapter we will stress the *expanded still life*—the idea of reaching beyond traditional subject matter. Specific methods for arranging a subject, the importance of viewpoint, and natural and artificial lighting strategies will also be given in-depth treatment. We'll offer some different ways of integrating subjects with backgrounds. In the demonstrations, which will focus on problem-solving aspects of composing and drawing in color, the basic working procedure outlined in Chapter 3 is followed. (These steps apply to work in any subject area.)

TANGERINES
Colored pencil on Rising Museum Board,
$10^3/8 \times 7^1/2$" (26 × 19 cm). Collection of the artist.

Contrast is a potent tool, and is an especially important one in this small still life. I arranged all the round tangerine shapes in the upper third of the composition, using an angular and active fabric pattern to contrast with them. I also included a solid red fabric to contrast with the patterned fabric. The conspicuous diagonal placement of it mitigates what might have become an overly static balance.

Selecting and Setting Up a Still Life

For artists attracted to this medium, there may be no more rewarding genre in which to work than the still life. As a group we tend to enjoy the challenge of realistically drawing difficult things. And still lifes offer many such opportunities. So, more often than not, we seek out subjects that have intricate forms and surface qualities.

THE EXPANDED STILL LIFE

The still life is an excellent genre with which to learn the basic art principles because the artist has complete control over the subject. But this control can sometimes evoke a certain academicism, too. The term "still life" may conjure up images of overly familiar subjects arranged and rendered in conventional ways. Although these objects can still be handled with fresh and contemporary treatments, it is also possible to come up with other subjects less readily thought of. An expanded still life is one that broadens the concept of what a still life should look like. And this can make it more personally relevant to you.

As you prepare to draw a still life, look around at the environment in which you live. Does the inside of your refrigerator speak of loneliness? Of suburban waste? Do you have a basement or garage shop crammed with tools? A junk drawer? All these things, too, are the stuff of still life. They may not be conventional subjects, but they do have the potential to be interesting or provocative subjects.

When you have decided what your subject will be, you will need to determine how considerations of form might refine, alter, or reinforce your idea. Relationships among shapes, sizes, colors, and textures will all have an impact. Usually the objects in your composition will have a hierarchy of importance that suggests their placement. Having all objects of similar size, shape, and color will greatly narrow your placement and handling options. Usually, however, one element quite clearly dominates over all others. Using the earlier mentioned refrigerator as an example, the inner boxiness, with control panel and shelves, might be our leading actor, with the contents less important. Or it could be the other way around, with contents looming large on a chilly stage as background.

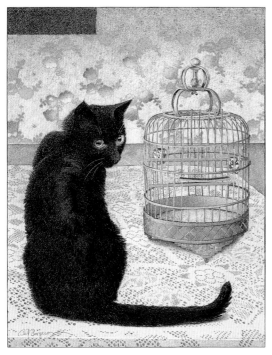

THE GREEN CAGE
Colored pencil on Rising Museum Board,
18 × 14¹/₄" (46 × 37 cm). Private collection.

This is an example of a more loosely interpreted still life. Traditionally, all elements in a still life are supposed to be inanimate, and the cat of course is not. But in this context, the provocative cat's image is meant to represent a concept.

VIEWPOINT REINFORCES YOUR CONCEPT

The viewpoint—the angle from which the still life is viewed—must also be determined. This can greatly influence a piece's overall mood, and provide a human scale to the scene. Here are a few possible choices:

1. *Close up.* A powerful perspective.

2. *Flat frontal.* Objects and setting at eye level.

3. *Forty-five-degree-high angle.* About halfway between bird's-eye view and frontal. This is the most commonly used.

4. *Forty-five-degree-low angle.* Between floor level and frontal. A child's view or a kneeling-down view.

5. *Extreme angles.* Viewed from way up or way down. Although dramatic, this viewpoint lessens the amount of visual information the viewer receives.

Lighting Your Still Life

Beginning artists often think it necessary to position a light on a setup, then dutifully render its light and shadow effects. Actually, the lighting of a setup is much more within your own control than this. There are, in fact, no hard and fast rules for lighting a setting. It all depends on what you want to communicate, and on keeping it credible. A wide range of lighting is possible to you—from just emerging out of darkness to brightly lit overall.

As an ideal beginning, a natural source of light will serve as a gentle and revealing light source. The drawback is that this light will change depending on time of day and weather. With experimentation, however, artificial lighting can be arranged to approximate the real thing. For this purpose, reflected light (bounced from a light-valued matboard or ceiling) is preferable to a direct light source.

Another option is to throw a single light on your setup, but to think of it as for your eyes only. This will help you see details and the light's direction. But instead of rendering exactly what you see— which will be harsh and perhaps poorly modeled— make these important changes:

- Include more detail and color in the shadows, gradate them more from the object outward, and soften their edges.

- Reduce the brilliance of highlights, not letting them totally bleach out the surface qualities of an element.

- Use your understanding of how form is modeled (as discussed in Chapter 2) as an overlay concept. In art, lighting's reality must often be modified in order to make it seem more real. Just as it is necessary to make departures from local color in art, it is sometimes necessary to depart from what might be called local lighting.

COSMOS
Colored pencil on
Rising Museum Board,
13 × 18¹/₂" (33 × 47 cm).
Private collection.

The light in this piece is entirely imaginary. And while not dramatic, it is still working hard. Conceived as art for a notecard, the image is meant to be cheerful and unobtrusive. The light quality is virtually directionless, and the cast shadow below merely a soft suggestion. A bolder or more real light might have been too burdensome in this context.

Integrating Subject and Background

One of still life's first charms is how it lets us focus on intricacies of form. But there is a drawback to this concentration on detail. Too frequently it causes us to "objectify"—to become so intent on a subject that we fail to see the whole space it occupies. Focus is brought too late (if at all) on the subject's background, which is then left empty, or tacked on only as an afterthought. This kind of objectification can lead to the subject looking pasted on to its background. Still lifes of this kind tend to look unfinished, and somewhat amateurish.

A still life's unity is improved, and a more appropriate relationship between subject and environment achieved, by remembering these principles of composition: A background is not a flat, two-dimensional element behind a subject. It is instead a three-dimensional space. A subject lies *within*, not propped against, its background. Also, it is important whenever possible to work the whole drawing together, not letting its subject plunge ahead alone. Adding background after the fact seldom deceives anyone (including the artist), and can drastically reduce the subject's impact. The idea of "working it all together" is another of the reasons for starting with thumbnail roughs.

The following are methods for integrating subjects with their backgrounds:

1. Use similarities of color and/or value as edge tie-ins.
2. Use a common color denominator for all color mixing of subject and background.
3. Use an overall background pattern.
4. Enlarge the subject, thus reducing negative space.
5. Blur some of a subject's outside contour edges.
6. Vignette or feather-out lesser parts of a subject into white negative space.
7. Tilt the viewpoint to reduce the negative space.
8. Echo hues and color temperatures back and forth from subject to background.

SWEETIE (IN PROGRESS)
Colored pencil on Strathmore Bristol board,
12$^{1}/_{2}$ × 9" (32 × 23 cm). Private collection.

A subject drawn with no thought given to background often seems like an isolated object centered in an empty rectangle. Merely adding a background will pose problems. Color and value decisions were based on the paper surrounding them. If a background were added, many of the original value decisions would be in conflict with the new background. This is why it is hard to arrive at a background color when a drawing has advanced this far without one.

Demonstration: A Still Life

My Aunt Wilmot always thought of herself as an actress. She lived in Culver City, California, where she worked for MGM Studios in its fan mail department, and sometimes as an extra in a movie. She also collected all kinds of stuff, and as a child I looked forward to visits with her, to listening to her movie stories over powdered doughnuts, and being much impressed with all the objects and clutter she managed to squeeze into her tiny house.

The idea for this still life is to suggest two things. First, there is the nostalgic look back at part of a childhood memory. Second, I wanted to enlarge on this first thought by suggesting a subtle narrative relationship among objects that might be evocative to others as well.

As I begin the preliminary work of laying out thumbnails and color scheme overlays, I look at the major elements from different angles. This viewpoint is a common one, and is what an adult might see when looking downward at small objects on a table.

This viewpoint is much lower, and now some of the objects are almost in profile. Although fewer of the elements are visible, I like this angle because it more nearly suggests a child's viewpoint. Even if this idea is missed by the viewer, it will still look somewhat intimate.

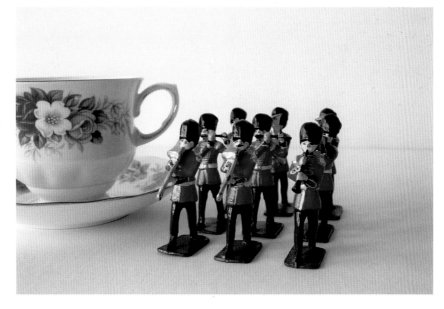

Step 1. Tonal drawing reveals any false starts or misplaced lines that may occur in the initial drawing stage. Therefore I like to work out a drawing's basic elements on an intermediate tracing sheet, then transfer these to drawing paper, rather then have early mistakes show as blemishes on the finished drawing.

Another benefit of tracing paper is that it can be cut into pieces, and elements moved around. Here I had to cut out and realign the cup and saucer so the cup's top ellipse was parallel to the picture plane.

Step 2. Transferring guidelines to the drawing sheet can be done with a lightbox or table (as shown) or with a daylit window. Even though my drawing sheet is a two-ply museum board, firmly drawn graphite lines show through it. (Inked lines on the tracing paper were only used here for photographic visibility.)

Both tracing and drawing papers have matching frames of reference, and when these are lined up, I tape them down together. Using a graphite pencil I very lightly trace the guidelines, ending up with a faint layout image on my drawing sheet. Most such light lines will not have to be erased later.

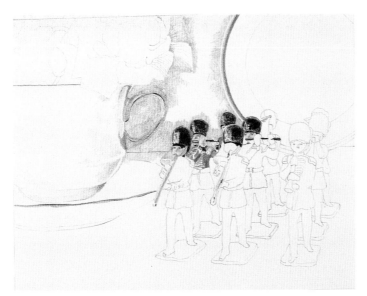

Step 3A. My plan is to establish color area by area, rather than element by element. Working alla prima ensures good continuity throughout. Things should coexist better, rather than appearing separate and seemingly appliqued against their background.

As I select an area in which to work, I first quickly lay down some of its surrounding or adjoining color. This enables me to make decisions about hue, value, and intensity relevant to this background color instead of to a white that is only temporary.

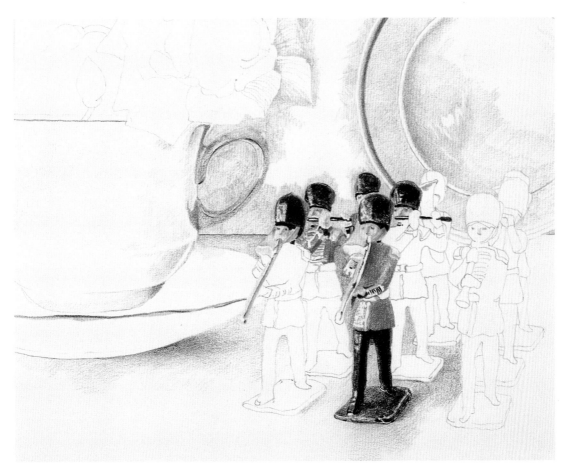

Step 3B. I continue adding color to additional areas, always being sure that there is some adjoining color in place. Where needed, I revise shapes slightly as I concentrate on color and form.

The saucer will be the next place to work, so I lay down some of the tabletop color and cast shadow in order to have some basis on which to judge its subtle value gradations. The tabletop value at the back of the saucer seems all right now, with a feeling that it recedes. But it may have to be darkened or lightened later as the saucer develops. My original setup cannot provide the answers I'm looking for. Only the drawing, as it develops, can tell me what adjustments are needed.

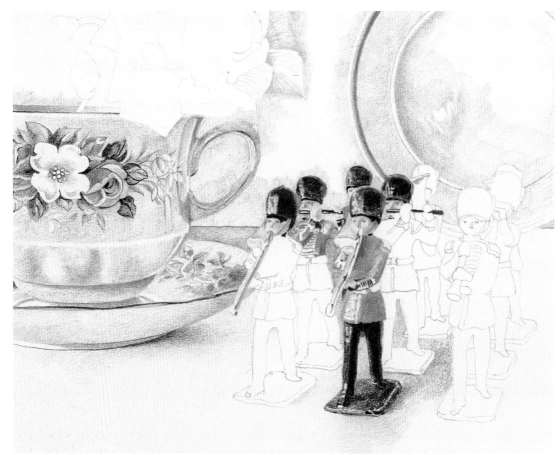

Step 4. The cup and saucer are turning out to be my most challenging elements. The soldiers are complex but the complexity itself is like a series of road signs telling me where to go with a line, an edge, or a color passage. The simple light-valued elements of cup and saucer, with their slow value gradations, make for more difficult rendering.

In this medium, it is often difficult to apply very light values with good control. I apply the light passages of the cup and saucer more darkly than wanted and with very sharp pencils, then lift excess color to get the desired lightness. The residual color is all that is needed.

There are many pencil choices for expressing white in shadow. Because I like to keep my lights cool I used a light violet with a light blue and some warmer colors to suggest reflected color from the soldier's coats.

But we have a *value problem*. Value has a special task in this piece—to provide a dark enough environment for the medium light cup and saucer to read as a slightly shaded white. But the negative space is now too light, causing the cup's handle to merge with its background, making it and the saucer appear too dark.

The sample values shown here represent the actual values in my drawing at this stage. The values of the background and of the cup and saucer are almost the same. The sample values at right reflect a change: the negative space value being darkened to contrast better with the cup and saucer, yet not so dark as to merge with the lead soldiers.

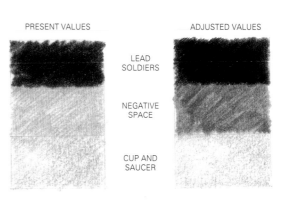

PRESENT VALUES

ADJUSTED VALUES

LEAD SOLDIERS

NEGATIVE SPACE

CUP AND SAUCER

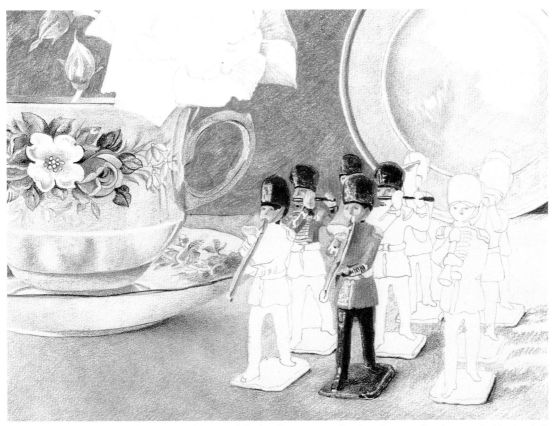

Step 5. I darken the negative space with my original yellow-green, allowing the pencil to be rounded instead of sharp. I juxtapose yellow-ochre, purple, a vivid yellow-green, and a dark beige to begin developing the tabletop. I plan to lift some of this at a later stage to further manipulate the table's surface. Now the cup and saucer begin to look lighter even though I haven't altered them.

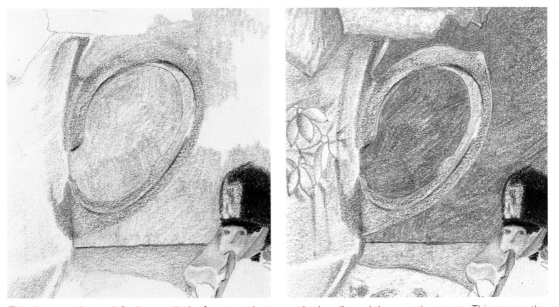

The close-up view at left shows a lack of contrast between the handle and the negative space. This causes the handle to appear too dark. The version at right, with negative space values darkened, presents a more appropriate contrast. The handle, which has not been altered, now appears lighter while still looking shaded.

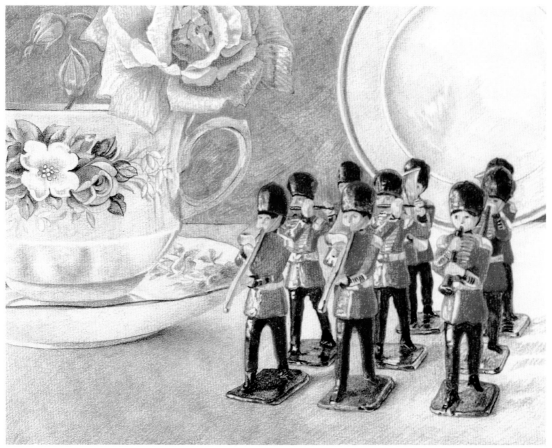

Step 6. I now apply color to the rose, relying on the background values to suggest how dark or how light it should be. Since the rose is not a major player, its values can be similar to the background's values.

I also establish the colors and forms of the soldiers. Although the light has changed, I use the center soldier drawn earlier as a model for where highlights and shade are placed on all the others.

In most of my work I try to strike a moderate balance between crispness and softness of edges by including different edge qualities. In this close-up view of the rose, a painterly edge can be seen as some of the orange color slips from the petal into the negative space. This kind of easing of edges helps create a more gentle effect where wanted, rather than an unrelenting hard edge throughout.

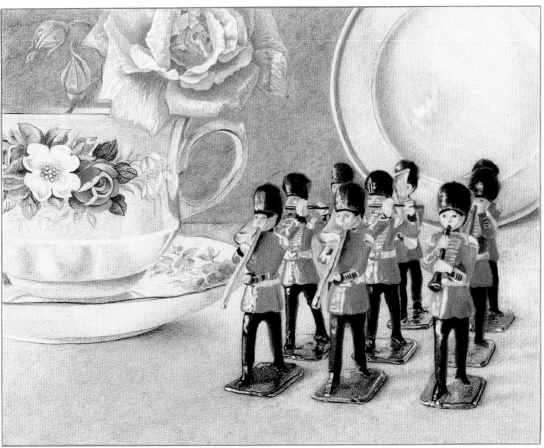

Step 7. After appraising the preceding stage of this drawing, two main tasks emerged for finishing it. The first was that white granular flecks all over the piece needed refining to increase color intensity. The second was that many of the darks needed additional darkening to increase the illusion of three-dimensional modeling of the various forms.

Scanning from top left to right: The darks of the flower and the right side of the cup were darkened using sharp pencils. I also lifted one of the cup's painted flowers and restated it in blue for added interest. The fairly coarse and open grain of the background was refined by putting two very intense greens (again with sharp points) into the white flecks. The plate was finished by restating what was there with a lower value, and putting in additional vivid colors.

On the tabletop, I lifted, added, and adjusted color, and finished the cast shadows of the soldiers. To make the lead soldiers more strongly take stage, I darkened darks and added some analogous colors to their uniforms. I also resisted the temptation to straighten out their badly painted faces and other details. This was a judgment call, and keeping these little relics true to their actual primitive state seemed in keeping with the nostalgic mood of this piece.

The Floral Still Life

Physical sustenance, medicinal properties, spiritual enrichment, and pure ornamentalism have historically supported the interest in flower and plant imagery. Although popularity of this wonderful genre ebbs and flows, artists continue to find in it an enduring charm, and a mirror of their culture.

ARRANGING A FLORAL STILL LIFE

When beginning a floral still life you will need to decide if the flowers are its central feature or just a supportive element. In either case, they should reflect your feelings and attitudes. The vase too is potentially an exciting part of a floral arrangement. It would be convenient to always have a perfectly suitable one of these at hand—but that usually is not the case. So what you will have to do, more often than not, is extrapolate from whatever vases are available to you. You can change silhouette, color, texture—even add decoration—using the original as a reference for modeling its basic form.

In my opinion it is best to arrange your own bouquet rather than draw from one designed by a florist, unless there is a thematic reason to do the latter. Your own sense of what you are after is more important than the florist's, who may be designing from a stock ideal. For formal bouquets, the main flowers rarely touch the lip of the vase, but instead stand more erectly, their stems evenly spaced and anchored by some hidden holding device. They often have a look of symmetry—or of determined asymmetry. Informal bouquets, although often just as rigorously arranged, try for opposite characteristics. Their goal is to appear both natural and casually splendid at the same time. Instead of erect and evenly spaced stems, they often bunch up, and flop over the vase lip. Keep in mind that you can freely add and subtract flowers and foliage as your drawing progresses.

Some cut flowers will last a week or longer. But even the most robust of them will change dramatically over time. Buds may open, and the gestures of flower heads change noticeably. Colors too can shift, lighten, and fade. If it is important to freeze a particular moment of your arrangement, you may have to lean somewhat on a photograph of it, or else work very fast.

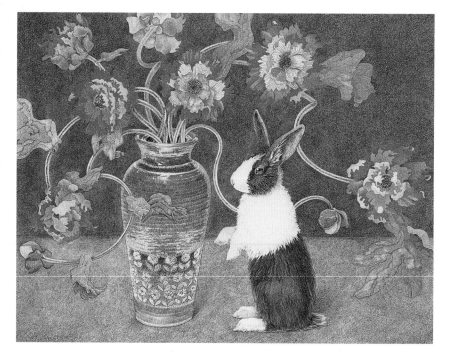

STANDING RABBIT
Colored pencil on Strathmore Bristol board, $19^1/_2 \times 25^1/_2$" (50×65 cm). Private collection.

Everything here is imaginary, except the vase. The bouquet is used as a strong supportive feature. Rabbits have been represented by artists since earliest times as fertility symbols or as mystical creatures. The latter appealed to me, so I placed him with wandering, almost-animate, flowers and stems to help suggest this.

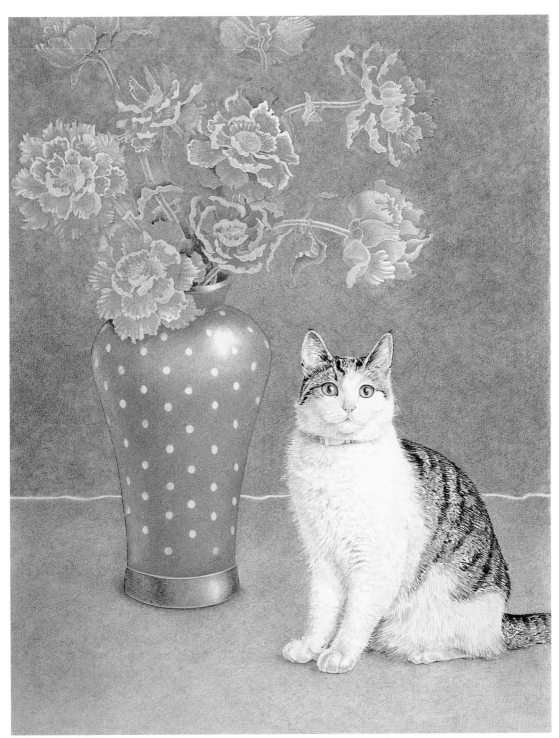

WATCHCAT
Colored pencil on
Rising Museum Board,
26 × 20" (66 × 51 cm).
Private collection.

This drawing is meant to be a portrait. The imaginary vase and flowers were used to connote a certain ornamentalism that I believe most cats embody. The vase was patterned after the vase in *Standing Rabbit* (opposite). For me, that vase has been a kind of "proto-vase," which I have used in various guises for many florals. This time, I pinched in its sides, changed the decoration to all-over dots, and made the ceramic base look like an added-on metallic base.

Demonstration:
A Floral Still Life

While looking for some textured material to put under a vase of flowers I planned to draw, I found instead an exquisite and exotic piece of fabric. It is an English screen-printed cotton with a primitivelike design of elephants and other motifs of India. I like it so much that I wanted it to be conspicuous rather than used as merely a suggestion of fabric. But I knew that only the boldest of vases and most intense flowers could stand up against this highly pictorial fabric.

My checkered ceramic pot, while not strictly a vase, seemed made to order for this project. While it is certainly bold (but not Indian) it has the kind of mercurial look that can go in many directions—from Romanesque to American Primitive—depending on what else is with it. At a flower market, I picked out some tropical antheria, ginger, Asiatic lilies, and palm fronds. All of this bold plant material seemed compatible with the Indian motif. But as I arranged the elements, the tropicals began to seem common, and the more subtle Asiatic lilies won out.

This is my thumbnail with tracing paper over it, representing my composition and color scheme. It allows me to foresee and head off any big upcoming problems. I can see already that my composition is in danger of dividing into two equal parts, even though it really does not. I also see that the blue color of the negative space is too different from the fabric. This will also divide the composition. To minimize this, I will try to match the values of the lower negative space with those of the tabletop. The hue of the negative space should also be warmed, and steered toward a bluish-gray.

Step 1. I first lightly lay out my guidelines with a graphite pencil. Good conservation practices dictate the use of at least a 1/4" of margin all around, rather than drawing to paper edges, then using a mat to crop the image.

Next I lay in some negative space and vase color as keys. Using my guidelines only for compositional positioning, I apply color quickly—without finesse—to describe the flower forms. This is a departure from my normal alla prima routine, but the lilies are changing fast. Decisions I make now will have to stand, so I spot in more highlights than I will later need to be sure I'm covered. I indicate dark areas and local colors but don't take time to fully develop them—for nature is quickly dismantling these delicate lilies. The buds, on the other hand, are plentiful and as most won't open, I can put off drawing them for awhile.

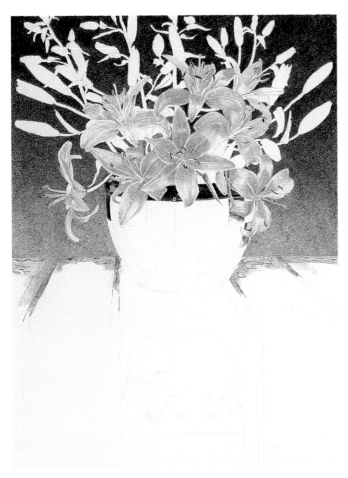

Step 2. I noticed that as I keyed in the negative space for reference, it was difficult to judge disconnected values that ultimately will be gradated. So I now put in some samples of the tabletop colors, then proceed to install the entire background colors with two layers. Of the two, a dark Prismacolor 901 indigo blue is applied first, very carefully. A 937 Tuscan red is then applied without attempting to fully cover the blue. Together these make a gradated near-gray, and will be more helpful in drawing and coloring the flowers and buds. But even more importantly, this drab and dark color will seem to heighten the colors of the flowers and buds.

Step 3. To inject vitality into the negative space I've planned to add some shapes of subtle color. To begin this process I use masking tape, lifting away enough color to leave lightly stained shapes. These are placed at various angles and "through" some flowers to appear randomly distributed. I float small pieces of tape onto the colored surface, careful to press only where I want lifts to occur. To create straight-edged angles I burnish tape edges as well as their interiors.

Lifting the angular shapes is completed, but they'll need to be recolored with various hues. For now I'll leave them uncolored until nearer the finish. At that time, after most of the fabric color is installed, I'll have a better idea of what hues to use in these spaces.

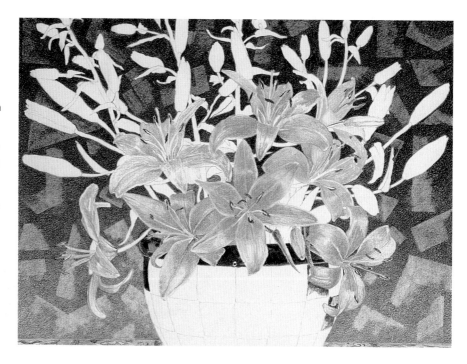

Step 4. I want the buds to glow out of a drab and dark negative space. I use light greens and yellow-greens to form the youngest buds and stems. To me, Prismacolor light greens have always had an unnatural appearance. So I use them to begin the glowing effect, rather than using natural greens of other brands. I begin making color choices for the more mature buds to try conveying that each of them is a separate thing while also part of a whole. I feel it's important to avoid formularizing their colors.

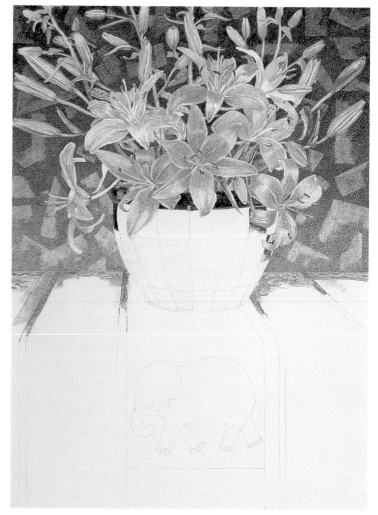

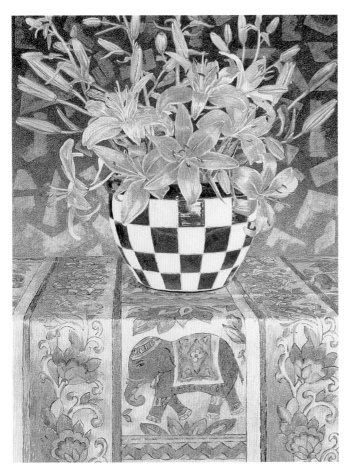

Step 5. My lighting is from a bank of windows directly in front of the setup and behind me. When a tablecloth is lit from slightly above and to one side, the top is light and the drop-off cloth is in shade. But in this composition I want to include the fabric's pattern as a strong feature, and to reveal the polished nature of the fabric. Direct frontal light works toward this. The bank of windows shows on the pot, however, like a little set of grinning teeth. My first task here is to eliminate all but one of these highlights. And although the pot's checkered pattern is very dark, I delay delivering these full darks for now, so the squares' waxy color surfaces won't bloom before I finish the drawing.

The screen-printed fabric has a hand-crafted look, but I won't concern myself with that just yet. My main focus now is to draw the design, establish colors without them becoming a main feature of the drawing, and to convincingly handle the depiction of light fall-off.

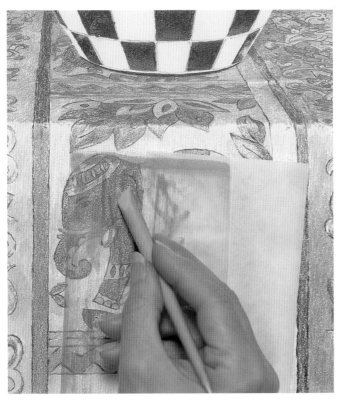

Step 6. To express the fabric's look of being screen-printed, with all its elegant imperfections, I decide to lift some of its color with frisket film and a wedge-shaped bone burnisher. Because the film is transparent I can see my progress. I want to lift enough color to simulate a light rough vertical pattern that I interpret as a squeegee passing across a printing screen. I use pieces of film that already have been used (shown), to reduce color pick-up, and to further add a mottled quality.

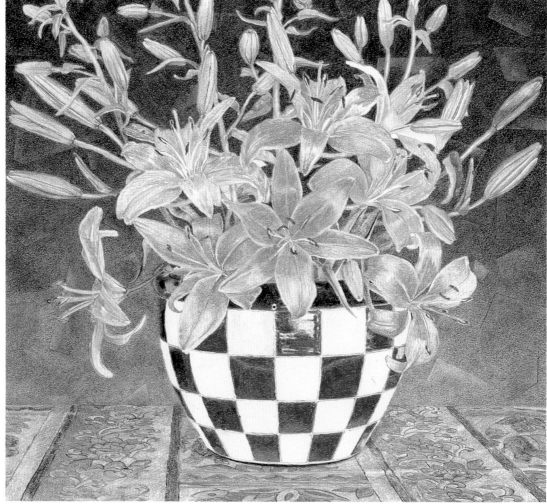

Step 7. Now I begin returning color to the lightened shapes in the background. I use very sharp pencils for optimum control, matching the values of new colors to surrounding values. Color choices are influenced by the fabric's scheme. For the first time I can really see the shape of the bouquet against its backdrop.

A Tip about Whites

For a straightforward white—one that isn't shaded—I use the white of the paper. But these whites pick up grime as I work alla prima on a drawing. Such grime can be turned to advantage, however, by thinking of it as the mass white. It can be darkened with light hues, and a white plastic eraser can produce a clean highlight.

My appraisal notes on the final drawing (facing page) indicated the following: "Complete flowers, darken pot's squares and clean up whites, darken lowest parts of the stems, and restate certain tabletop colors." The flowers were my main concern. Using original colors as a guide—much as an underpainting is used—I applied Prismacolor reds for the mass flower colors. I reduced white flecks on the petals by lightly stroking sharp Lyra oranges on top of reds. Lyra Rembrandt Polycolor pencils seem a little harder and weaker in hue saturation than the Prismacolor pencils, so they can be useful as colored blenders and grain reducers.

Finally, I tried for a balance between highly defined and more relaxed edges. I think this variety produces a generous effect—a feeling of splendid artlessness, still with some authority.

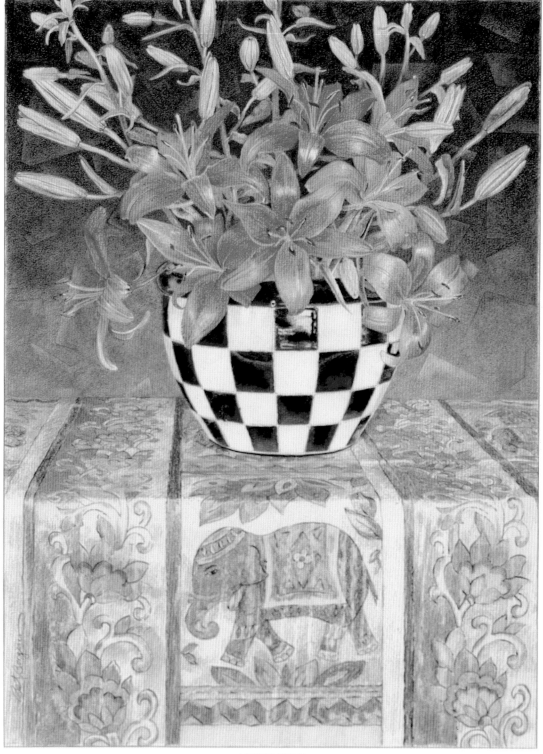

ASIATIC LILIES
Colored pencil on Rising Museum Board,
17 × 13" (43 × 33 cm). Collection of the artist.

Landscape

There is a power about landscape. In whatever part of the world we live, the natural landscapes around us can evoke deep feelings in artists and nonartists alike. And the colored pencil medium—simplicity itself with its freshness and versatility—is supremely up to the task of expressing whatever wonder we feel.

In this chapter we'll deal with such issues as whether and how to handle landscape work on location or in the studio, how to find settings of special significance, and how to use color's advancing and receding properties to suggest and describe space. We'll discuss three major ways of approaching landscape.

With the first of these, the minimalistic way, which is essentially a reductionist process, we'll introduce the concept of macro- and micro-editing of your raw visual information. Next, we'll expand and build on this new and more spare way of working as we explore a naturalistic vision. And finally by linking minimalism, realism, and your own personal sense of logic, we'll offer a way of approaching the imaginary and fantastic in your landscape.

STORYTELLERS
Colored pencil on Rising Museum Board,
23 × 16¹/₂" (58 × 42 cm). Collection of the artist.

To stand beneath trees like these can be a very powerful yet intimate experience. The complex mood generated is probably due more to the overhead canopy than to anything else. It is an effect, however, that cannot be shown as successfully with a photograph.

Because the canopy itself seemed beyond the scope of my composition, I relied on implying it by drawing its effects—chiefly its lighting. I also avoided using heavy outside contour edges. For when the trees' edges come and go, merge and emerge, it evokes the enveloping feeling I first felt. And hard, well-defined edges usually promote an effect of appliqué or separateness.

The Rooms of Landscape

Among landscape designers, different parts of a large yard or garden are often referred to as "rooms." Use of this word can help to previsualize the scope of a project—the canopy, the path, the large elements, the small textures, the overall mood. It is a way of organizing a smaller place out of a larger one, of converting a thing of overwhelming scale into human scale.

Thinking in terms of the rooms of landscape can also be very helpful when beginning to draw landscapes. It can help us see that a scene is not merely a backdrop, but like any other room, is a three-dimensional, volumetric space. And this in turn reminds us that to translate it onto a drawing surface we must be in charge of its arrangement of elements. To express our own particular vision of a chosen setting we must locate a center of interest, then edit by adding, subtracting, and rearranging, to some extent, in the manner of a landscape (or room) designer.

BIG LANDSCAPES, SMALL PENCIL POINTS

Students have told me that they would like to draw landscapes with colored pencils but, although this medium is mobile and easy to use on location, they feel intimidated by the thought of rendering large-scale scenes with small pencil points.

Because I once shared this feeling I can empathize with it. It does no good to offer the logic that a drawing sheet is the same size surface whether covered with a portrait or landscape, or that a pencil can render a faraway thicket as readily as nestling hair around ears and neck.

What helped me get over this notion was a kind of sneaking up on landscape by including fragments of it in compositions that were not themselves landscapes. For about a year I added small, simple landscapes off balconies, out windows, and through open doors while drawing animals, florals, still lifes, and interiors. As my confidence grew, these small landscapes grew larger, finally becoming the subjects.

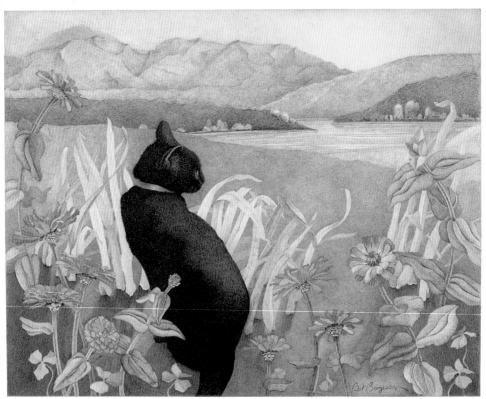

CAT AND LANDSCAPE
Colored pencil on
Strathmore Bristol Board,
20 × 25¹/₂" (51 × 65 cm).
Private collection.

This drawing employs landscape as a definer of mood rather than as a principal player. The cat is my center of interest and I wanted to show her enigmatic quality by trying to draw her enigmatic essence instead of merely details of her fur. To reinforce this idea I situated her within a minimal landscape, itself devoid of detail.

NIGHTVIEW
Colored pencil on
Rising Museum Board,
17 × 12" (43 × 31 cm).
Private collection.

A recommendation sometimes offered to artists new to portraiture is to ease into it by first doing profiles rather than full faces. I once borrowed this advice for myself, applying it to landscape. This scene of an interior with flowers is an early example, and is one of many I did before moving on to full landscapes.

Working from Location to Studio

Most of art history's masterful landscapes were accomplished in one of two ways: they were begun on location and then finished in the studio, or they were composed and executed entirely in the studio from carefully annotated outdoor studies. In today's lifestyles, we are usually pretty short on time for ourselves, and hiking in woodlands or deserts may not have appeal for some. The fact is, weather and time handicaps have always been a limiting factor for artists. And even more important, color conceived outdoors does not look the same when brought indoors. Landscape art has always included a great deal of studio work.

KEEP EQUIPMENT SPARE

When you have a little time for exploring or drawing in the field, plan to bring all your favorite and most reliable drawing materials. Include a camera if you can to make some reference photos for work to be done in the studio. If you plan to photograph only, rather than actually draw, you'll still need to make some color notes or rough studies for good studio results. This will require ten to twelve colored pencils, a small hand-held manual or battery-operated sharpener, and a drawing tablet.

Your choice of pencil colors will depend on the kind of landscape you expect to encounter. A desert scene and a Pacific Northwest forest require very different palettes. The idea is to limit your note making pencils so that you'll be dealing with fewer color decisions while out in the field. For an Oregon farmland scene, for instance, I would use ten pencils (all Prismacolor) to be able to achieve the twelve hues of a traditional color wheel (although not necessarily at spectrum strength). Here is how this could be done:

- blue — 903 true blue
- blue-green — 903 true blue + 911 olive green
- green — 911 olive green
- yellow-green — 913 spring green
- yellow — 942 yellow ochre
- yellow-orange — 1003 Spanish orange
- orange — 1003 Spanish orange + 923 scarlet lake
- red-orange — 923 scarlet lake
- red — 937 Tuscan red + 923 scarlet lake
- red-violet — 929 pink
- violet — 932 violet
- blue-violet — 903 true blue + 932 violet
- darkener — 901 indigo blue
- lightener — the paper itself

These ten pencils would, by no means, represent all the colors you would likely see in your landscape scene. But additional colors can be mixed, or you can note names and numbers of specific pencils you can use later. You can also try one of the pencils at hand, and note what it would need added to it to approximate the local color you see. These color notations are most effective when you are familiar with all the pencils you normally use—an ability you will develop with surprising rapidity.

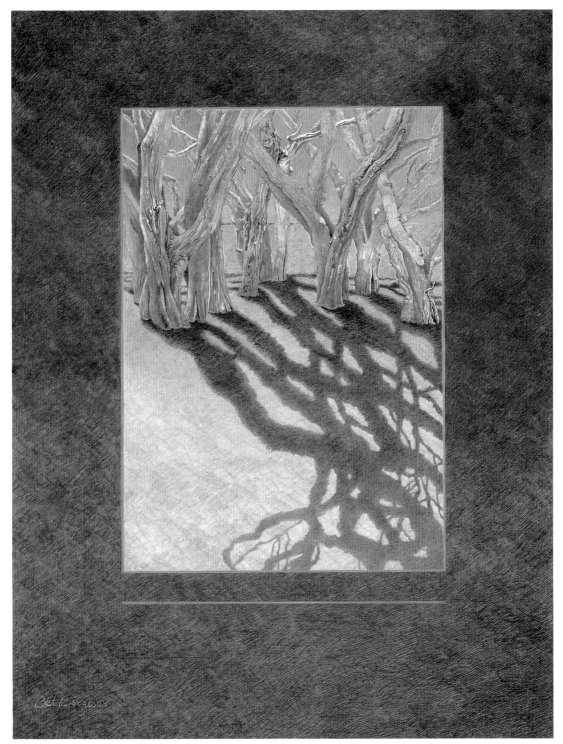

SHADOWS
Colored pencil on Rising
Gallery 100 (smooth) paper,
25 × 19" (64 × 48 cm).
Collection of the artist.

Seeing a group of trees in a busy downtown area, I took a snapshot and soon forgot about it. Years later I found the picture, with no color notes. Again, fascinated by the play of shadows, I decided to try basing a drawing on that feature alone, leaving out the urban surroundings. As the photo had only washed-out color and no color notes, I decided to veer away from the natural, and planned for a more striking color scheme. To reinforce the drawing's eccentric nature, I included a drawn "mat" around the trees and their shadows.

Tips

As you drive on errands and trips always be on the lookout for interesting settings. Keep a notepad and pen clipped to your car's sun visor or in the glove compartment. Pinpoint good locations (mileage posts are helpful), the date, time of day, and your ideas—for a possible return at a better time with camera and/or drawing materials.

- Scenes often are better in early morning, or late afternoon and early evening when the play of light and shade, and cast shadows are at their most dramatic.

- Increase you palette by piggy-backing your pencils. Wrap two or three similar colors together with a rubber band. Draw with wanted pencils without undoing the band that keeps them organized.

- When working from a moving vehicle, contain pencil shavings by using a manual sharpener inside a plastic sandwich bag.

- Whether drawing in a notebook, tablet, or on a large sheet of paper, draw your frame(s) of reference ahead of time so you don't have to do it in the field.

A useful kit for photographing scenes might include the following:

- A 35 mm single lens reflex camera with a normal lens and a built-in meter. (New cameras are complex, cost a great deal, and are not really necessary. Excellent used ones can be found at surprisingly low prices.)

- A lens shade (to minimize light flare).

- Film (low-speed films yield sharper pictures, and also cost less).

- A shoulder bag or a small backpack to carry camera, film, lens shade, and so on. (You'll have to carry the tripod yourself.)

This snapshot shows part of my neighbor's front yard. The combination of the two plants makes for a pleasant confusion of white iris and blue hydrangeas. I like its contrasts and draw different seasonal versions of it. It is the basis for my drawing *Nikkos and Stardust* (on facing page).

When I work with a scene I try to compose a dramatic view to tell more about it, or my experience of it, than a mere inventory of its physical characteristics. Its reality serves as a baseline to which I must add and subtract other elements. In this case that has meant leaving out the sidewalk, the garage, and wilted white iris blooms that would not contrast with the hydrangeas, even were they in peak condition. I add red ones instead, with a stylized night sky and stardust. The focus is where blooms interact with the night sky. Everything else—contrasts between round domelike hydrangea flowers and vertical iris blooms, round leaves and leaf spears—is only supportive.

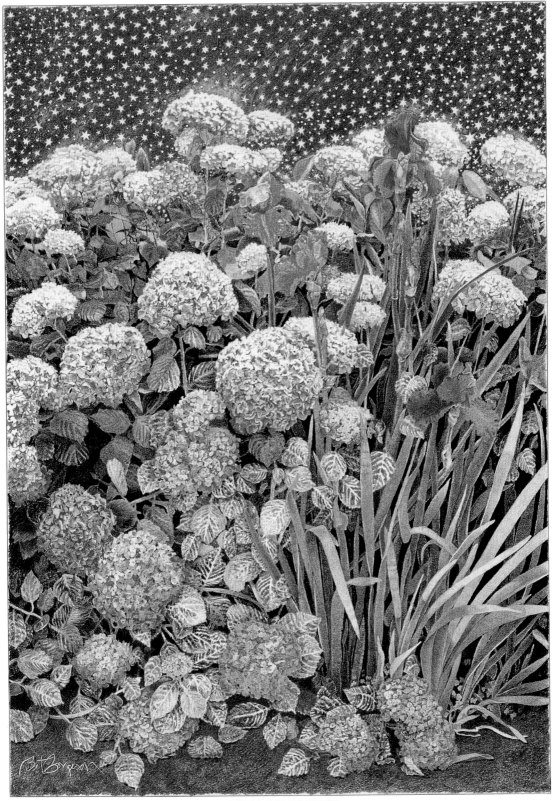

NIKKOS AND STARDUST
Colored pencil on Rising Museum Board,
19 × 13¹/₂" (48 × 34 cm). Collection of the artist.

Finding Your Setting and Center of Interest

Gaining technical expertise in any medium is a fairly straightforward matter. The real difficulty—the mind-teasing problem—lies in deciding what it is that you want to express. Although themes may evolve and change over time, one usually has a core of beliefs that is constant, however obscured or underdeveloped.

Finding one's own voice can be immensely satisfying. This is a process that can be greatly aided by understanding the major movements and thrusts of any chosen category of endeavor. In landscape, there are generally considered to be five such areas. They are (1) landscape as a descriptive element; (2) as a decorative background; (3) as a structural aid to

THE PERCHERON AND THE RABBIT
Colored pencil on Rising Museum Board, 18¹/₂ × 24" (47 × 61 cm). Collection of Washington State Arts Commission, Art in Public Places Program in partnership with Manitou Elementary School.

Drawings of animals within my landscape are metaphors for human relationships and states of mind. In this piece I am trying to evoke the idea of how tentative many of us are toward each other. The drafthorse, although powerful, and seemingly in charge of any situation, appears willing to accord the rabbit—a symbol of timidity—a respectful distance and much interest.

composition; (4) as a central theme; and (5) as an expression of mood. In any particular work, two or more of these are often combined.

What you must ask yourself is how you personally relate to such major movements. Are you a storyteller using landscape as a dramatic setting? Or are you a historian wanting to visually describe nature in transition, or as apocalyptically threatened? You may discover what intrigues you most by mentally visiting some of the rooms of landscape. As you read this partial list of rooms, let your mind provide images for each:

- pathway
- intimate garden
- woodland clearing
- canopied forest
- sentinel tree (or fence, hummock, and so on)
- night landscape
- faded rural landscape
- devastated (or fantastic) scene
- vista (mountain, desert, farmland, sea, and so on)
- urban setting

Remember too as you scan these that physical viewpoint is an important factor—omniscient, human eye level, critter level, whatever.

THE SCENE IS NOT THE CENTER OF INTEREST

Landscape art sometimes disappoints for reasons that seem hard to pin down. Because as an artist you are no longer a civilian, you must try to figure out what is wrong with a failed piece—your own or someone else's. Landscapes often fail because the scene itself was believed to be the center of interest. It almost never is. The real center of interest probably exists somewhere within the scene. Your task as an artist is to find (or create) it, then express it emphatically. Convey your excitement or mood in a landscape scene by identifying for yourself exactly what it is that makes this scene so eye-filling in life, then exaggerate this. Point it up. But be specific. A center of interest—the focal point—might be a physical thing (a gnarled tree among others with less character), a repetitive element (row upon row of a farmer's crop), an evocative lighting situation (the moon between rim-lit branches), or a special relationship that suggests a concept (confined plants all vying for a meager patch of sunlight). Once you know what is making your heart beat faster, you can begin to eliminate any elements that pull attention away from it. You can begin to edit the scene, using everything you know to promote and enhance your chosen critical feature.

Using Color to Suggest Space

Color's properties of seeming to advance and recede make it extremely useful in creating spatial transitions—in leading a viewer's eye from foreground to middle ground to background, for instance. While space in portraiture, still life, interiors, and so on, is usually rather shallow, in landscape it must often seem deeper and more complex.

Here again are some of the general characteristics of advancing and receding colors, with an additional note regarding lightness in landscape.

To make things advance use:

- warm colors
- high-intensity (or vivid, pure, saturated) color
- light values
- isolated, unrelated color
- line(s), outlines
- coarse texture or texture in sharp focus
- patterns
- active, busy color

To make things recede use:

- cool colors
- low-intensity (muted, dull) colors
- dark values
- closely related colors
- tonal areas
- fine or generalized texture
- absence of pattern
- passive, quiet color (changes made slowly)

In general use, light tends to advance. Therefore, in most areas of landscape work, lights and darks are employed in a straightforward way. But there is an exception. When representing a great distance, such as that of a vista or faraway plane, light retreats. So it is possible within a single drawing to use lightness for advancing in a foreground, and also for receding in the farthest part of a background.

A particularly difficult situation is the use of lightness for a "lighted glen" in a landscape's middle ground or farther. Such lightness tends to advance,

making it often necessary to add other devices for keeping it firmly in place. Strategies for this might include a strong overlapping element in front, a dramatic darkness in front, or whatever other ingenious devices of persuasion you might want to enlist.

CREATING DEPTH WITH JUXTAPOSED COLORS

Juxtaposing colors rather than layering them can be a great time saver. And in landscape work it may also be the best possible way to communicate depth. By depth I am refering not to large vistas, but to elements such as large whole trees and voluminous shrubbery.

To create a feeling of three-dimensional branching wood, twigs, leaves—some in front, some in back, all coiling and twisting—we can use the advancing and receding properties of pieces of unlayered color. But it's helpful to know in advance how your collection of unlayered pencil colors will act in relation to one another.

For my own use, I have made up some cards (using the same paper on which I draw) specific to various hue families with samples of all the different colored pencil brands I generally use. My green one, for example, encompasses all my greens, including the yellowish and bluish greens.

The samples are gradated and identified, and at a glance I can see which pencil colors bounce forward and which retreat. It is by juxtaposing colors that seem to sit on different planes that the spatial effect occurs. As an example of this, a vivid Prismacolor 1006 parrot green in the midst of other warm and/or vivid greens can be placed at the front of a tree's green canopy, then a coolish Lyra 600-58 sea green with other cool, dull, and dark pencil colors placed at the rear to suggest the tree's depth and complexity. The actual local color of the tree would remain to dominate and communicate the nature of the tree's colors—with the others used to create the needed feeling of space.

GREEN

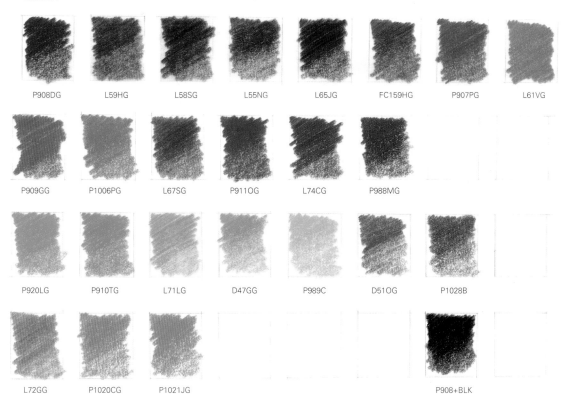

P908DG	L59HG	L58SG	L55NG	L65JG	FC159HG	P907PG	L61VG
P909GG	P1006PG	L67SG	P911OG	L74CG	P988MG		
P920LG	P910TG	L71LG	D47GG	P989C	D51OG	P1028B	
L72GG	P1020CG	P1021JG				P908+BLK	

P Prismacolor
L Lyra Rembrandt Polycolor
D Derwent
FC Faber-Castell

I have never found methodical charts of color mixtures very useful. This is because color is always relative to other colors, not isolated on a white chart. But charts of *unmixed* color are another matter. These show what colors are available, and this is very useful indeed when juxtaposing a single layer of many colors rather than applying multiple layers of color. I often use juxtaposed colors in landscape work. It is a great saving of time, of course. But more importantly, I believe that adept juxtaposing of colors actually models form and indicates distance more efficiently than layering.

Make your own color charts. These don't have to be elegant. They can be rough and informal, so long as they show you the colors you tend to maintain in your palette. Make your own gradated samples, specific to hue families—all your greens, for instance. It's also a good idea to spray your charts with two light coats of a fixative, so your color samples won't bloom.

The Eloquence of Understatement

Understatement in a visual sense refers to imagery that communicates or evokes the essence of a subject while including very little detail. It may be its very spareness that encourages a viewer to actively participate in the experience the artist is trying to convey. For when art is profusely detailed, there is little remaining for the viewer to participate in, leaving the artwork's effect to be experienced only secondhand.

To achieve this quality of understatement, the artist must first come to grips with a subject's essence, then remove all things that dilute it, and emphasize critical relationships. In other words, the artist must edit. Although we have mentioned this before, its special significance for those of us working in colored pencil warrants a fuller explanation of the process.

In landscape art the need for editing becomes particularly essential. Moving a tree or adjusting the bend in a river for compositional reasons is a familiar form of editing. I think of this as "macro-editing." But there is more. A second level of editing also exists, one that might be called "micro-editing." This more elusive form is the editing of minutia. It is the gathering together and distilling of the countless natural facts found in order to evoke a simpler, less cluttered, yet sometimes even greater fact.

MACRO-EDITING

When we set out to draw on location, or even when we study a photo reference, it can seem almost impossible to know where to begin sorting through all the visual information nature so readily hands us. Our first order of business is to look for simple divisions, for masses of elements. These can be based on similarities of shape, value, color, texture or spatial relationships, or any other things that make sense.

If this is a new concept for you, start practicing it as you go about your daily routine. Try mentally organizing the natural scenes around you into three or four simple divisions. Avoid looking at details. Link items together based on shape, value, and so on. This is macro-editing.

MICRO-EDITING

As you grow more adept at editing the big picture, try reinterpreting the myriad of nature's small details into simpler and stronger versions of themselves. This is micro-editing, and it means leaving out redundancies of detail, while stressing only those that are critical for successful communication. Primary, secondary, and tertiary highlights, for example, might be scattered willy-nilly throughout a scene. Most must be eliminated, or greatly deemphasized. The same is true of textures, such as those of trees and bushes, or any other too-plentiful details. Deciding what stays in and what gets cut out of your landscape is the fun part—and it's always your call.

A BEGINNING—THE MINIMAL LANDSCAPE

Artists working with brushes approach landscape work with the need for editing so obvious that they hardly need think about it. But artists who work with pen or pencil are usually more draftsmanship oriented, and must keep the concept of reducing detail constantly in mind. An excellent way to combine drawing with practice at macro- and micro-editing is with the minimal landscape.

This is an idiom that celebrates color, shape, edges, texture, spatial relationships, even process itself. We start with the largest questions of purpose, see the grossest simple masses or divisions of a scene, then sift through its details to extract and simplify just enough information to communicate what is wanted. For many mature artists, working in many mediums, the minimalistic landscape is not merely a precursor to other work, but is itself the ultimate expression.

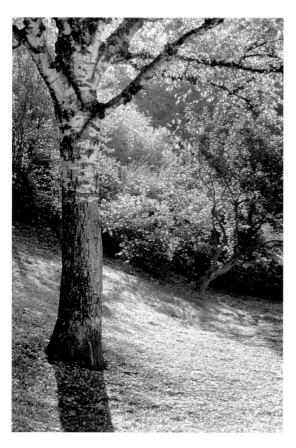

Among notable elements in this parklike setting are an odd division of bark on the foreground tree, pink foliage in the middle ground, and a pattern of shadows contrasting with sparkling highlights on the plants and small tree. All would probably agree that these are the scene's most defining elements. But from here on, opinions would likely differ on how to interpret it all—on what to emphasize and deemphasize. And this is as it should be.

For my part, although the large tree might be interesting enough to feature, I like the pink foliage, and want to exaggerate its color and the color of the adjoining background. I also feel that the cast shadows should be emphasized, or at least clarified.

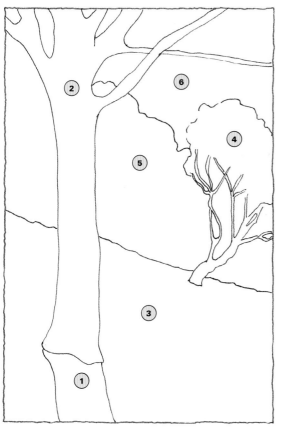

When looking at most scenes, I organize spatial elements in my mind. Details usually appear so abundant, and chaotic, that I strive for clarity right away by organizing the space. Another artist might start with a different rationale—shapes or color, for example—and arrive at different divisions. While I don't usually draw a schematic plan for minimal work, I include one here to indicate how I have *spatially* divided this scene. Number 1, for example, represents the shape nearest the frontal plane, while number 6 represents the shape farthest back.

The close-up detail (left) is from the middle of the minimal landscape drawing (opposite). It clearly shows how the micro-editing described earlier is used to express only a distillation and generalization of detail. Compare this with the same detail area enlarged from the scene's actual photograph (below left). In this case the small details seen in the photograph were subordinated to gesture, value changes, color, and masses of shapes. There was no attempt made to minutely describe superfluous details.

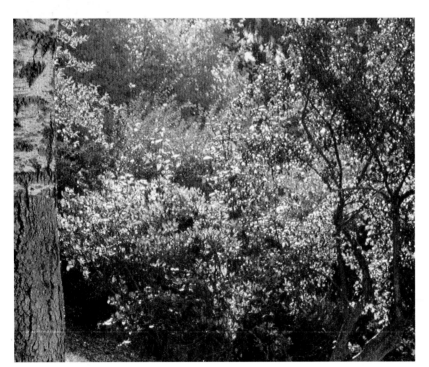

This little study (opposite) took only a short time to do. To see what was left out, added, or changed, compare it with the photo on page 93. Although the drawing was done swiftly, it could have been larger, with more thought and finesse, and still be minimalistic. A more natural interpretation of the scene would have required more detail, although still somewhat simplified. A treatment in high realism would have required some macro-editing, but much less micro-editing and more complete rendering of detail.

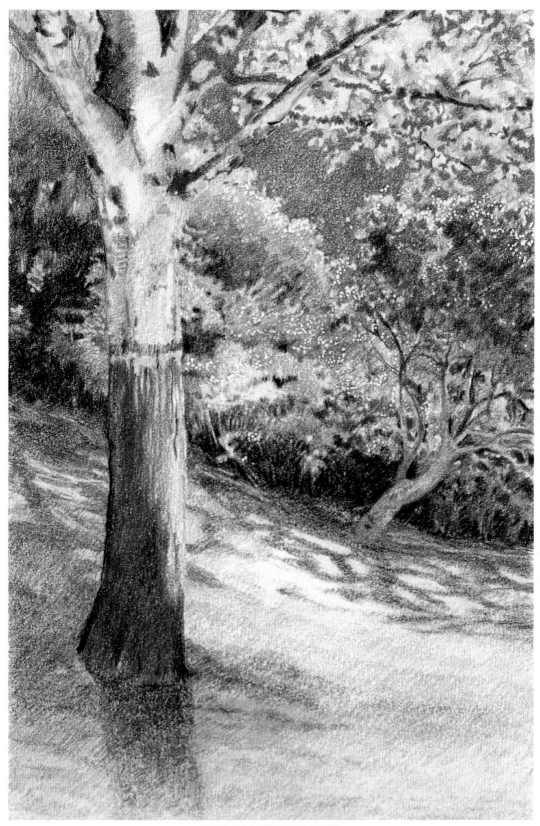

MINIMAL LANDSCAPE STUDY
Colored pencil on Rising Museum Board,
$10^{1}/_{2} \times 7$" (27×18 cm). Collection of the artist.

RUNNING AWAY
Colored pencil on
Rising Museum Board,
25¹/₂ × 19" (65 × 48 cm).
Private collection.

This drawing bridges some of the differences between minimal and natural landscapes. Although most details have been reduced, enough of them remain to carry the whole image into a more natural format. Compare it with the minimal study on preceding pages, and later with the naturalistic demonstration. The amount of detail you customarily use will become a part of what makes up your style and vision.

The Naturalistic Landscape

In the minimal landscape the underpinnings or foundation of a scene are emphasized. The naturalistic format allows for more representation of facts and subtleties. It also allows for a greater moving of elements, and of exaggerating colors or whatever, to more fully reflect the scene's original feeling.

Demonstration:
A Natural Landscape

When driving down from Oregon into northern California on Interstate 5 there appears an area of landscape transition that is extremely dramatic. While the coast and valleys of the Pacific Northwest are characterized by a moderate and moist atmosphere, the interior of northern California changes rapidly to a hot and dry climate. Verdancy becomes aridity. Greens become yellows. Because I have long been fascinated by the look of this thermal landscape, I have photographed it, made some notes, and now draw it.

Some Work Tips

When you must work with intense concentration over several hours, break up your work time. This is also good body mechanics. Set a timer for twenty-minute intervals. Then stand up if you are sitting, or sit if you are standing. Look into a distance, letting your eyes relax as they drift into focus on some small dark thing. This will help rest your eyes. Also, as you return to drawing, try relaxing your shoulders, then your face. This last because even though we cannot consciously relax our eyes, they tend to stop straining when our faces relax.

This is the scene I plan to draw. From the photograph you can see how dry and barren the low hills appear, and perhaps appreciate how different it is from Oregon's Rogue Valley to its north. While this time the scene shows a typically cloudless sky, I have also seen it with clouds, and plan to add some of them because I like the dramatic contradiction between cloudiness and dry land.

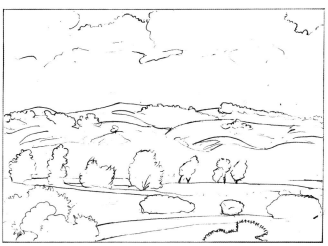

Step 1. These preliminary guidelines of the landscape's basic features are a facsimilie of those on my drawing sheet, which are layed in too lightly with graphite to be reproduced. They show how minimal the drawing is at this early stage. Elements are simply assigned their positions, and clouds barely indicated. The guidelines also show changes from reality in the foreground. Because I don't want the closer road to zoom up from the bottom left corner, I am adding vegetation there based on some across the roads. A second plant is also added to reduce the asphalt element, this one extrapolated from a plant to its right.

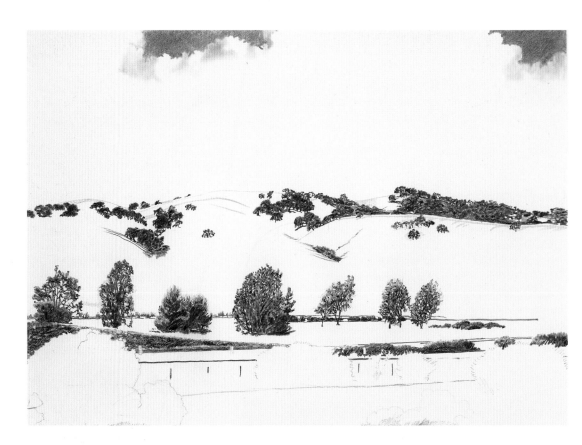

Step 2. In this next early step, I establish with blue and green pencils where the darkest areas are to be. These will later be further darkened. I lay in some yellow behind the trees, to both provide a clue to what these areas will later look like and to place them credibly behind the lacy tree foliage. I try out a sepia colored pencil, and decide it to be a good choice for the cloud-shaded earth of the foreground and hills.

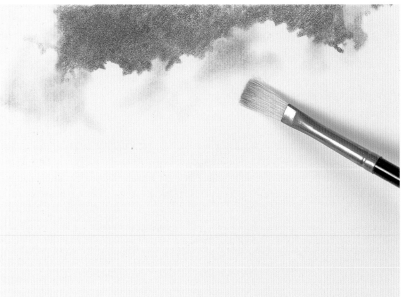

Sky detail. Tonal work on medium grain paper often generates a graininess that for elements such as clouds is unacceptable. To minimize this, I use Faber-Castell and Lyra Rembrandt Polycolor pencils, both of which can be easily smudged. With a hog's bristle brush (as shown) or a cotton swab, pigment can be subtly moved, blended, and feathered showing only a minimum of grain.

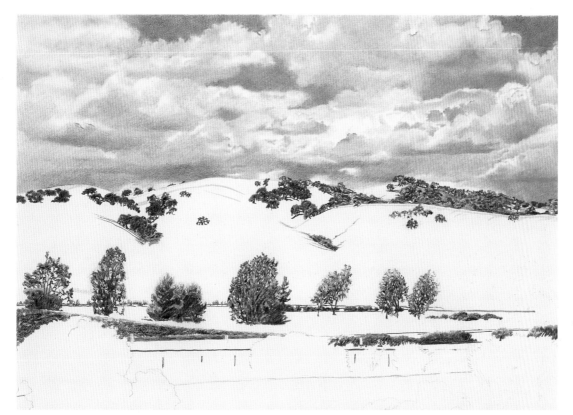

Step 3. The clouds will be a major element in this landscape, and will probably demand more time, energy, and thought than any other element. In student work, I often see skies that are given short shrift in preference for land features. I see pencils used with long horizontal swings to quickly dispatch large areas of sky, rather than used in small increments while monitoring pressure and point sharpness for the needs of a sky illusion. The sad likelihood is that when we artists grow bored by or detached from our work, our viewers will also be.

Something to Note

I used a graphite pencil mixed in with dark colored pencils for rendering the earth and asphalt. Think of graphite pencil as another colored pencil. Surprisingly, it doesn't read as gray in the company of colored pencils, but seems instead more to resemble a very low-intensity green. It also behaves like a chameleon when close to colors of medium to dark values. Graphite has a marvelously liquidlike laydown, is compatible with all brands of colored pencils, and with it you can sculpt clean fine edges. About its only drawback is that too much of it will have a metallic glint that colored pencils do not have. For my own use, I favor the HB grade.

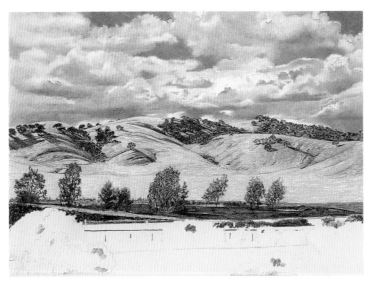

Step 4. Moving to the hills I apply two yellows, a dull one for the hills themselves, and a more intense yellow—Prismacolor's 1003 Spanish yellow—as the hills flatten toward the middle ground. Both of these are applied quickly, without maintaining any particular pencil sharpness. Using graphite and a sepia colored pencil I also begin to delineate some of the cast shadows and additional foreground (see detail below).

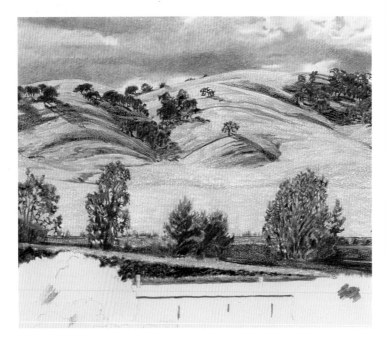

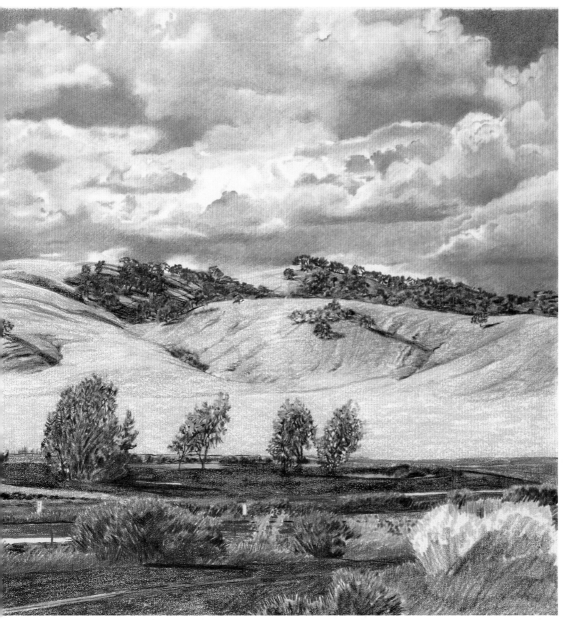

Step 5. I now take the foreground area—asphalt and median strip plantings—to a lower value. My drawing is looking very undistinguished right now. Drawings sometimes go through clumsy stages. As we begin early on to use color that is to be covered or refined, color schemes and draftsmanship can seem on very shaky footing. It often takes steady nerves to avoid losing the spirit it will take to bring it all together.

But the main task in this step is to establish colors in the foreground that are beginning to appear dark, yet intense enough to retain their hue identity when dramatically darkened later. Two of the foreground plants are left undeveloped, showing how roughly and quickly the rendering process can be begun. Like the whole drawing, single elements too can go through states that are very inelegant.

Sky detail. A sky is like the ceiling of a vast room. It has volume, and the cloud forms have perspective. The top of a sky is nearest the viewer, the horizon farthest away. Sometimes when I look at clouds I am amazed at how few rules seem to govern their structure. Practically any and every condition can be seen. Edges can be light, gray, or even hue-laden. Some can be crisp and some diaphanous, all in the same sky. If there are rules for rendering clouds, they have been developed by artists to create an illusion of reality, and are akin to the rules of classical modeling.

A difficult concept to master when drawing skies is that of lowering the value of clouds generally so that only certain critical areas can shine out brilliantly. As we cannot apply a white pencil to do this, we must rely on the white of the paper. In this detail, the lightest point is around point A. Other "white" clouds are actually a bit darker, because too much white in too many places would degrade the power a key highlight should have.

To keep light areas pristine, it helps to gently press a protective piece of frisket film over it until you are ready to draw in that area. And when spraying a finished drawing it also helps to shade pure white areas from the spray.

Detail 1. Drawing a cloud-filled sky depends on illusion for its credibility. Each cloud or grouping has perspective and can be modeled to represent its three-dimensionality. In this area I drew the lower whole cloud form smaller to suggest distance. Compare it with the larger (and nearer) cloud at the drawing's top right. I also darkened the cloud's lower part to indicate its three-dimensional nature. I've done this in other sky areas as well.

Detail 2. The sky contains many colors, and so do clouds. In portraying sky and clouds, it is often useful to include some colors from the land below. This detail contains warm scarlet red as a cue to the cloud being in front of the cloud beneath it. Lacking this cue, the two forms might have seemed connected.

Detail 3. Every manner of edge quality can be found in a sky. In this close-up detail there are several. A mainstay of classical modeling is a well-defined and shaded top edge placed in front of a lighter area. There are three groupings of these shown here. Remember, all the characteristics and features of a drawn sky are for the most part imaginary. You can therefore position the cues you need anywhere that seems appropriate.

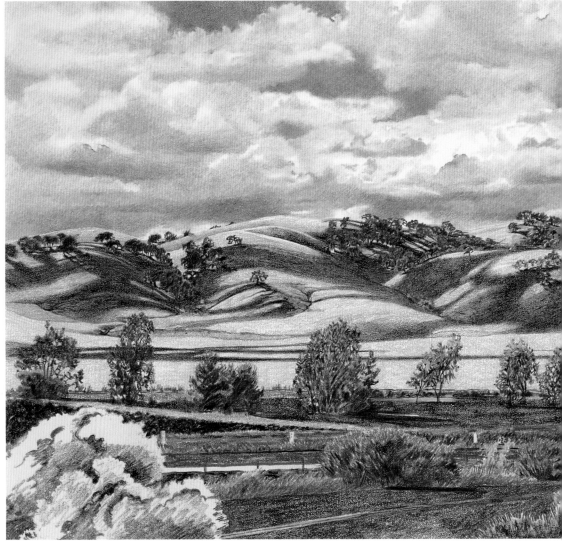

Step 6. Working alla prima I leave the foreground in mid-development, working now on the shadows cast by the clouds. These dark forms on the hills and in the foreground will help create dramatic light effects.

The cast shadows are not in my reference photo (there being no clouds). But by calling to mind prior observation, I know they should be characterized by soft edges, by a look of transparency, and by closely following contours of the land. I rely on a sharply pointed sepia colored pencil right over the yellow to describe these shapes. I also add a little ultramarine to cool them slightly.

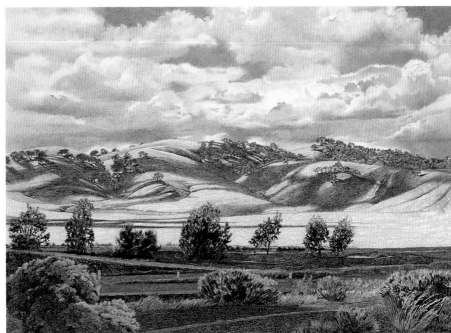

Step 7. With the hills' dark cast shadows in place, the mood seems closer to what I remember. These dark shapes will also serve as keys to how dark the foreground must go.

Using a Prismacolor black pencil, I darken the darks already established with earlier pencils. When applying refining colors—such as the black in this case—I try to maintain point sharpness to create a uniform grain. (Compare the dense grain pattern of the shaded areas with the open and irregular grain of the yellows.)

The bushes left at an early stage are now finished, using warm and cool colors. I am relying on simple interpretations of light and dark values to suggest the foliage. Because the bush at left occupies an important place in the composition—where the eye begins scanning from left to right—it gets more detail. The bushes at right are much less rendered.

Plant detail. This enlarged view is of the farthest right foreground plants. The oats in front of the larger plant are drawn negatively with a color lifting technique. In this technique, dark colors are applied first. Then with frisket film over the area, a double-ball stylus is used to draw the oats. When the film is lifted away it pulls up the dark color in the linear shapes of the oats. This is another example of micro-editing—exact detail being subordinated to overall gesture and character.

SHADED GOLD
Colored Pencil on
Rising Museum Board,
12 × 17" (30 × 43 cm).
Collection of the artist.

Step 8. Before making a final appraisal of this piece, I completed the darkening of the trees. I then felt I could take it into another room and make some completion notes. It seemed that the intense blue in the sky needed to be drabbed a bit. Doing this, and slightly warming it, might also improve the overall color scheme. In the lower right foreground my effort to suggest a small portion of unobstructed light looked ambiguous. A better defined value contrast was needed here.

A more important discovery was that the cast shadows on the hills were too warm. They presented an impression of scorched earth rather than shade. An addition of blue would help.

As I began correcting these concerns, I began also to mull over whether or not this drawing was too hard-edged. It would be a fairly simple matter to ease some edges and blur some shapes. But when I reflected more on the character and impression the real hills make—hot and arid with crystal clear vistas—I decided to keep the hard edges. This is not a romantic land.

The Imaginary Landscape

Artwork that is purely imaginary is disarming, and artists who work in this format can express ideas and experiences in ways that more realistic formats cannot approach. Yet while imagination, invention, fantasy, and improvisation may all come into play here, the strategies used for it are no different from those used in most other expressed art. For example in the preceding demonstration of a natural landscape, the clouds, the cast shadows, and some of the plants were all imaginary. Yet the piece remains a *natural* interpretation of the original scene. So why doesn't it look like an imaginary landscape?

The answer is this: The various components in the piece—realistic and imagined—are all rendered logically, and linked together with logic. An imaginary work, on the other hand, contains its own logic, rather than that of the external world. It is conceived and executed from the artist's own personal and idiosyncratic brand of logic. It is in imaginary work that we can give free reign to memories, dreams, recurring snippets of mental images, and feelings profound or playful.

COMPOSING FROM IMAGINATION

As in any other area of art, constructing the composition for an imaginary or fantasy piece must aim at communicating an idea or experience. But instead of adhering to the physical realities of a real scene, we now have complete freedom to create our own scene.

Some compositions are conjured up from no apparent references at all save those in the artist's mind. More likely, however, is that an artist will begin with actual studies and/or references. In my own case, I might use references for a physical situation I can't quite see in my mind's eye—such as an eroded earthen bank as seen from below.

But if there is one overwhelming feature in successful imaginary work it is that its compositions are dramatic. And usually emphatically so. Although we always try for emphasis and de-emphasis in our work, in this format these things are approached with much more magnification and strength. Goodness is not merely good, but noble; darkness not merely dark, but black—for this is a genre of extremes.

Here are two photo references of real trees with a quality about them of make-believe. If I were going out in the field to draw an actual place, I would probably avoid a scene with these trees. It would not seem believable. On the other hand, either tree might seem quite at home in a fantasy landscape.

FINDING MAGIC
Colored pencil on
Rising Museum Board,
$25^1/_2 \times 20$" (65 × 51 cm).
Private collection.

Finding Magic—a purely imaginary landscape—is an example of an open narrative. It suggests a scene from a story, but the story itself is not established or known, and must be added by a viewer. What I wanted to do was construct an image containing elements of mystical wonder and solemnity. Because no references were used, I kept the image within a minimal format, relying on symbolism rather than details of reality.

Demonstration:
A Fantasy Night Landscape

Early nightfall is an especially dynamic time outdoors. Our sensory system for full rich daylight colors switches to one more sensitive to value changes and less to hues and intensities. But we know too that the beauty of early darkness is double-edged. This quiet drama of nature can also seem threatening.

To mitigate any sense of such threat here my plan is to use a broadness of style—almost cartoony. By suggesting that all this is not to be taken too seriously, I will try to make what might seem too spooky more like a place in which to linger, not afraid of the dark.

This portion of a tree was photographed at the Los Angeles Zoo. What I liked about it was its antlerlike structure and its surface roots, suggesting a sweep of forms that might be useful in a drawing. So I will borrow its overall gesture, but not lean on the photo's specific information.

Because my style usually favors the spareness of minimalism, I often use simple line studies from life to help select details of a plant that evoke its total image without rendering it all. I try to include various views of leaves, flowers or bracts, stems and stalks—plus some notations. In this fantasy landscape, I plan to use Zantedeschia—or callas—quite prominently.

Step 1. At this first stage in a fantasy piece, I try to become acquainted with its various parts. Working loosely from a somewhat tentative thumbnail, I know that in fantasy work there will be discoveries along the way to steer the drawing in other directions. So things must remain fluid. Even now I find that I am arranging the tree at an angle on a hummock of earth, rather than on a flat stable ridge as originally planned. I also add a triangular shape of distant land at the left because the effect of steepness may now be too pronounced. This, I tell myself, can be removed later if the composition needs more dynamism.

Below the tree and its roots I lightly draw with graphite a clump of rhyzomous callas, referring to the line sketches from my file. The big challenge, when so many of one thing is being drawn, is to somehow draw them all differently. The urge to use a formula on similar forms must be strenuously avoided. Each spathe and leaf must be stated as an individual, even though as a group they all look much alike. I decide to leave them for awhile, and try out some color choices in the sky, the tree, and land.

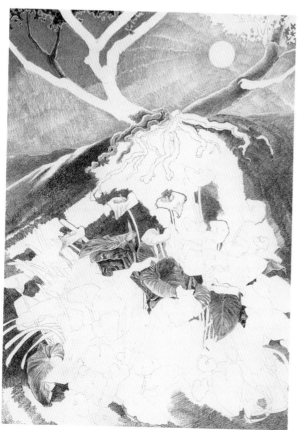

Step 2. Imaginary drawings tell us what they need. Our job is to be receptive to their cues. I continue to explore notions of how dark to make the earth, tree branches, and sky. A good way to communicate early evening is to put land and tree forms into near-silhouette, and let the actual night sky appear lighter and more intense than one might expect.

When the blue of the sky was laid in earlier, I noticed that the accidental placement of ribbing in my tonal application looked like emanations of light. Working on it now, I wonder if this might help set the mood. Or will it look too much like rays from a sun, or just too corny? In any event, it can remain for now a judgment call nearer the end. I also begin to test some greens—warmest at the top of the clump of callas, and cooling as they move downward.

Step 3. I now focus on the top part of my composition. For the tree I use various warm and cool dark colors to establish the branches and their spatial positioning. I use light-valued color on branch edges to suggest three-dimensional form. I strike for minimalism and use well understood visual symbols for such details as leaves and knots.

I also apply more color in the sky, maintaining the ribbing effect. I see that a misty moon may be better than the yellow moon earlier envisioned, and am relieved that it really looks like a moon and not a sun.

When I stand back and look at the whole piece, I begin to see how the moonlight must wash over the top of the flowers, not fully illuminating the very bottom of the clump. I try to fix in my mind how the callas need to appear to be emerging out of darkness, yet clearly visible.

112

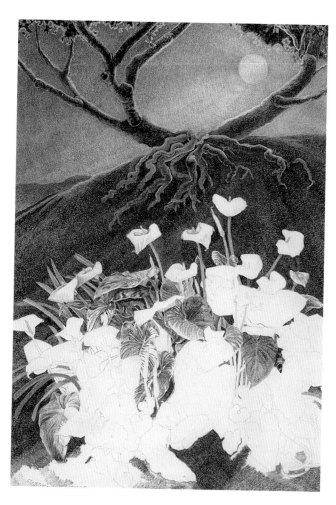

Step 4. I extend color into the tree roots after redrawing some of their shapes. In imaginary work, roots can be used to suggest all sorts of emotional states and moods. I try to defuse any feeling of threat, but want also to keep them from appearing too lively. Another aspect of roots is that they can accidentally take on wrong shapes—such as human hands, legs, torsos. In this case, the setting's low illumination will probably squelch any undesired associations.

Part of rendering roots is accomplished by applying color to the surrounding earth. As I model this rounded knoll, I again use color in roughly ribbed shapes similar to those emanating from the moon. It now seems a nice repetition.

I also begin to define more leaves and spathes, using mostly single layers of different greens, with frequent checking of my green sample chart. I will later layer over these leaves with darker colors.

Earth detail. Here's a close-up of the earth's colored ribbing mentioned above. An effect of ribbing happens when pencil strokes are allowed to extend in one direction longer than usual. (Here it is vertical and dark. In the sky it is horizontal and light.) Succeeding rows of strokes are then begun above or below the first strokes, slightly overlapping them. It is the overlapped edges that create a look of ribbing. Since my earth element is planned to be bare, this added textural feature may serve as a nicely subtle complication.

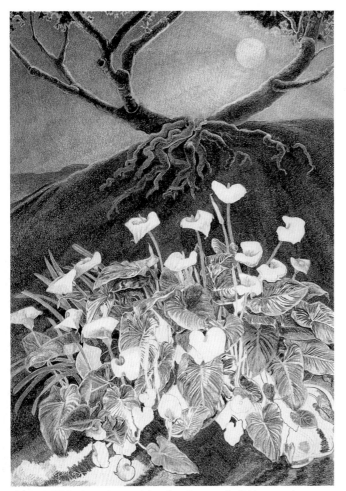

Step 5. At the lower part of the drawing, earth ribbing can be seen in progress. My real task here however is to state in color all of the different leaves, stems, and spathes of the callas. I keep values light as I work at defining their shapes and forms, for I'll need to see whole forms first in order to logically darken them. But I must point out that this is a purely personal way of working. Another artist might as readily be able to darken the forms as they are initially drawn, instead of later as a second step.

Step 6. To complete this fantasy landscape my work centered on the following five tasks:

1. Maintaining sharp pencil leads, I refined the sky texture so the moon's rays were less emphatic although still quite visible.

2. Because the rim lighting of the tree leaves was not contrasting effectively with the sky, I applied some dark blue and black over these mushy light areas.

3. I continued to apply color to the clump of callas, always darkening their forms. The warm cast of the paper serves well to describe the creamy whiteness of the spathes. I added light blues and violets to further model them, and to darken some of those nearer the bottom of the clump.

4. With all the greens of the foliage in place, I decided to include an additional green in the little triangle of land at the left horizon. Some voids can be useful, but others can seem just plain empty and need filling. Adding a green glow here helps to slow the eye, probably a needed thing because this drawing visually is so easily grasped.

5. Finally, I restated all the darks— on tree bark and landmass—using original colors in some passages and differing colors in others. I used sharp dark pencils, but no heavy pressure, to get darks that are not shiny. My earlier darks had bloomed, so this stroking of additional color also served to remove any fogginess. I ended by spraying the finished drawing with one coat of Lascaux-Fix to ward off any future blooming.

Looking at this finished piece now I see that the callas could have been darkened more at the bottom. Their forms in fact might have been made all but invisible in a darker night sky, with only a few tall sentinel spathes breaking out into light. But I see also that this would be another drawing, another story for a different time.

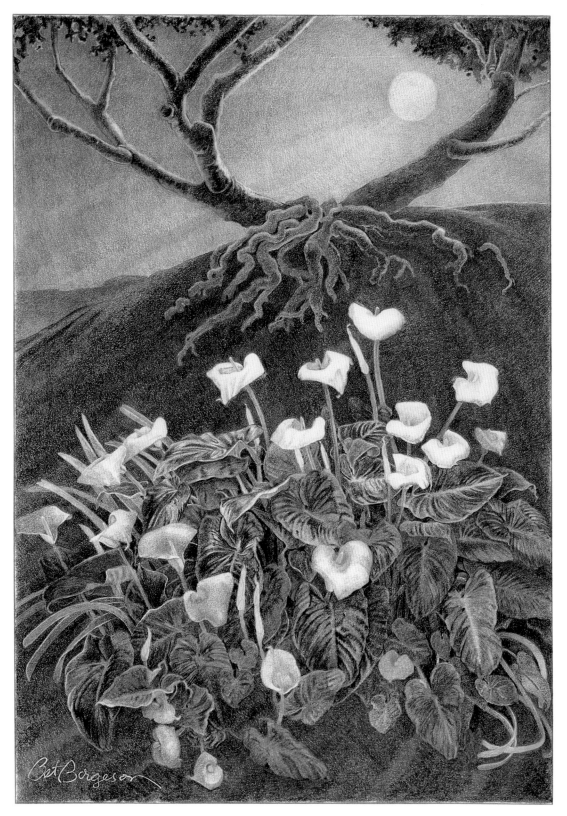

CALLA LILY LIGHT
Colored pencil on Rising Stonehenge (warm white) paper,
17 × 12" (43 × 25 cm). Collection of the artist.

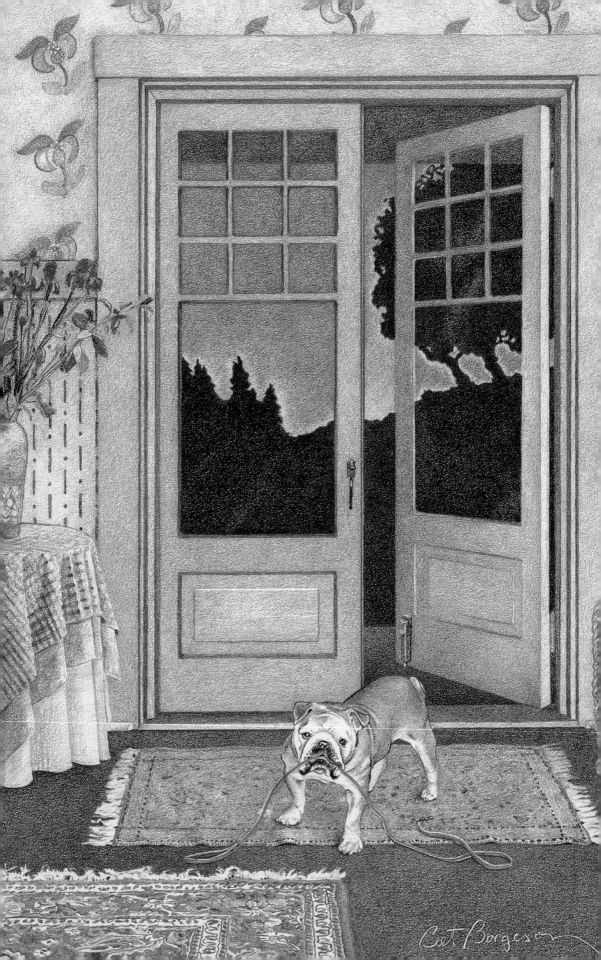

Cet Borgeson

Afterword: Art and Independence

Confidence is a mercurial emotion. But it can be strengthened through preparation—and that is what this chapter is about. For even now, if you are making a serious beginning at art, or at a new medium of art, you will want to realistically know about some of your lifelong career options and choices.

We'll begin with some basic philosophy from which to consider how a life in art can be blended with the needs of earning a livelihood. There are several time-tested ways of doing this, and we'll look at some of them with their strengths and weaknesses. We'll look, too, at other issues that impact the sustaining of art, issues such as having enough energy and personal discipline, handling rejection, dealing with self-doubt, and living through fallow periods.

Then we'll describe as specifically as possible, within our limitations of space, such professional concerns as the channels of commerce for art, the arithmetic of pricing artwork, and how to approach a gallery. We'll discuss the importance of laddering multiple goals to spread your art wins and losses over the long haul, rather than attaching all your feelings of worth to a single goal. And finally, we'll hope to convince you that being an artist is not just one thing, but is a way of life and of thinking, and is part of a long and worthy tradition.

LATE WALK
Colored pencil on Strathmore
Bristol Board, 16 × 12" (41 × 31 cm).
Private collection.

Becoming a Lifelong Artist

Newcomers to art have often told me—after a certain amount of hesitation—that they'd like to make some money with their fine art. I now believe that it's something else they really want, something harder to put into words. What they are truly seeking, I believe, is a way of living their lives in art. But because our society is so money oriented, it is difficult to separate these two issues—to say that one wants to do something with a cost in time, energy, and commitment, and not attach a money-earning string to it.

In a sense, they are correct. Most of us need to earn or supplement a livelihood. What is wrong is the difference in emphasis between these two ways of stating what is wanted. And this difference can mean fulfillment or failure.

New artists who attach money-making to their work as a primary motive for doing it often risk going public too soon. Commercial pressures quickly grow intense. And even if the whole enterprise is not sabotaged, a sense of desperation soon leads to thinking of one's artwork as primarily a "product," and of oneself as more of a manufacturer than an artist.

This is not to oppose the earning of money with artwork. But when the emphasis is changed, and you know that what you actually want is to become a lifelong artist, then your challenge becomes how to accomplish that.

ART TAKES YOU UP

There is an ancient adage (and somehow a comforting one) that we don't take up art—rather art takes us up. When this happens, although family and friends think we have a choice in whether or not we want to live as artists, we begin to suspect we may not. So it becomes critical to get a handle on how to manage this without too much frustration, and maybe without too much stress for your family.

New artists often seem to believe that art is an all-or-nothing venture. This need not be true. There are at least five workable strategies for helping to design a sustainable life in art, and we'll soon discuss some of the pros and cons of these.

But first we must remember that there are many more manifestations of being an artist than any single version, fashioned often in youth, and based on youthful preconceptions. In a single lifetime, each of us may spend long or short periods as a gallery artist, a student, a teacher, a graphic artist or commercial illustrator, an inventor, an art entrepreneur, or at any of a number of other art-related activities. To rigidly attempt conforming to a false idea, formed young, of what it means (and looks like) to be an artist can have an embittering and devastating impact on our lives, our artwork, and the lives of those we love.

ART AND INDEPENDENCE

Independence in our time has usually come to mean—or at least to imply—financial. But useful as financial independence can be to a life in art (or anything else too, maybe), it cannot by itself guarantee the motivation, energy, and discipline needed for true achievement. For this you will also need other kinds of independence. You will need courage, self-confidence, optimism, and the independence that comes with knowing who you are, what you are doing, and where you are going.

Fashioning a truly personal independence of spirit has probably never been more difficult to do than now in these times. Finding a satisfying niche in society—being respected and appreciated for what you are doing (rather than what you are getting) has become an elusive pursuit. Maybe once it was easily possible to live in very modest circumstances, eschewing the trappings of a middle-class life, and still be honestly admired for dedication to vocation and principles. It wouldn't be easy now. Instead, we are all of us pressured constantly and pervasively—in subtle and not so subtle ways—to appear successful financially, if we want ourselves and our work to be taken seriously. There has never before been a time when the linkage of art production to the making of money has been so intractable.

We must cultivate a steadfastness and a determination to acquire what I like to think of as artistic independence. It is also survival-wise to work at patience, perseverance, and an organizational flair. What about the talent that some believe to be the whole story? In the long haul of a lifetime, our talent, skill, and originality will usually prove to be merely our openers.

Blending Art with Livelihood

In my opinion, the three most important requirements for living a life in art are (1) time and its management, (2) financial equilibrium, and (3) physical and emotional energy.

TIME AND ITS MANAGEMENT

The real problem is never having too little time, but is instead, almost always a matter of properly using the time we have. For time is finite. We all have the same number of hours each day. And right now may be as good a time as any to start shaking off the notion that money is what buys productive time. There are individuals who are well-financed who still cannot seem to find enough time for their art. What really buys the time needed for art is careful management. Artists who find the time for their

work, whatever their other circumstances, have learned to think of it over months, and even years. They have also learned to be flexible, varying strategies as necessary, and knowing that too rigid a management can become itself a serious problem.

FINANCIAL EQUILIBRIUM

This refers to having the financial part of your life in some sort of balance. It means not being so consumed by money needs that you cannot think of much else. If we could view the life structures of many lifetime artists we would likely see combinations of five major strategies. All assume a need to earn or supplement a living. They are the following (beginning with the most frequently used, and ending with the least so):

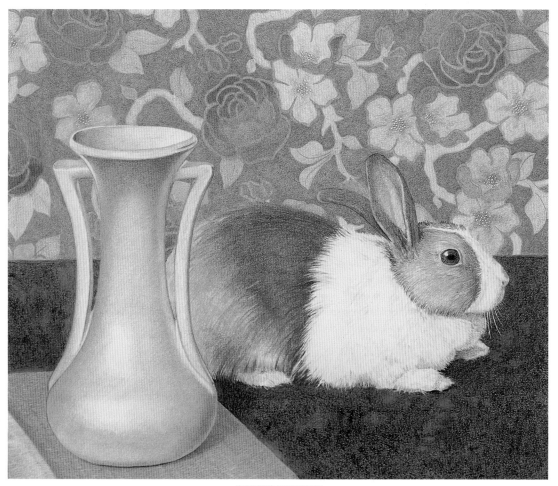

RABBIT AND VASE
Colored pencil on Rising Museum Board,
13¹/₂ × 16 (34 × 41 cm). Collection of the artist.

Working in stints. A stint is an amount of time regularly scheduled into one's daily waking hours—for example, rising at five a.m. for two hours of work before breakfast. It can be carried on over weeks, months, or more, and may be the oldest known method for accomplishing something quite separate from work done for livelihood. Whenever and for however long or short a time each day's stint occupies, the reason for this strategy's success is that the artist and other family members soon view the time as fixed and inviolate. Its great advantage for a serious beginner is that it begins what can become a lifetime in art immediately and compellingly, with no threat to other sources of livelihood or family routines.

Working two part-time jobs—an outside job, and your art job. If you are single, or need only to supplement income for livelihood, this may be a good strategy for you. It means finding part-time outside work, but then rigorously considering your art work to be your true occupation. Together the two comprise full-time work. The basis for success with this strategy hinges greatly on your ability to regard time spent at art as a bona fide job, with fixed hours and goals.

The tough part is avoiding employment—that requires so much emotional and social energy that it overshadows your lonelier job at art. Staying detached, saving energy for art, may mean making your outside job one with fewer responsibilities, and maybe with lower status.

Working a year on, then a year off. A variation of this one is taking seasonal work, then using off seasons for working at art. Artists who successfully use this strategy swear by it and feel it is not as outlandish as it sounds. Should you wonder what advantage there might be in a strategy so counter to our culture's way of working, there are two. The first is garnering large blocks of time in which to gain momentum. Trying to work and develop artistically in small and disjointed chunks of time retards progress. This is not to say progress will be negated, but it will be slowed.

The second advantage is that when you have gone public and are selling in a gallery or other context, you will be able to compete on a more level playing field with full-time artists.

Postponing full-time work at art. This means deferring full-time status in art until circumstances allow no dependence on new earnings. The deferment period can be from a few years to several.

Many successful artists have deferred their art careers, gained financial security, then gone on to a professional level with a solid financial cushion. The important thing is to keep interest and motive alive, to increase skills with reading, art classes, practice at art whenever possible, and occasional entrance into competitions. Artists with this strategy are generally characterized by an ability to take a long view, and to balance their emotional needs for a life in art with the needs of family life.

Grants, residencies, sponsorships, and so on. This strategy has a pretty strict set of requirements, is highly competitive, and can in fact become almost a career in itself in a subculture of its own. Basically, this is not a plan for a long period of time, and works best as a supplement. Organizations that sponsor artists can be found by researching the topic at the library or on the Internet, as well as through some art periodicals.

PHYSICAL AND EMOTIONAL ENERGY

Productive energy levels differ from one individual to another. Each of us must learn to know and protect this like any other expendable resource. Our fast-moving, status-conscious, and extremely acquisitive culture places heavy tests on the emotional energy and stamina needed for artwork. Other obstacles can arrive in the form of physical ailments, depression, anxiety, and chronic fatigue.

But the great thief of time and energy now is a more subtle adversary, one that can slip up on us without warning. It is the middle-class existence. Throwing large amounts of energy into club activities, out-of-town weddings, home redecorating, extra jobs to finance entertainments, clothing, or a second house are not unworthy activities. They are simply inconsistent with wanting to be a serious artist. A lot of emotional wear and tear can be saved by knowing what we really want from art—a relaxing and enjoyable hobby, or a more serious vocation—and focusing our energies accordingly.

FULL-TIME ART RIGHT NOW

If you can work at art full-time immediately, you will probably still need strategies for making the most of your time. For, however enthusiastically begun, such time almost always has to compete a whole lot with other perceived responsibilities of living a modern life.

And there is another factor. Artwork—particularly in the beginning, but sometimes long afterward as well—has very little outer structure. Beyond a few

tools and materials, and maybe a limited workspace, it can quickly become an abstract and lonely pursuit.

For this reason, I believe it is necessary to add as much closely related structure as possible to our art time. What is needed is a tangible and self-directed program of specific targets, goals, and deadlines to make it all more real.

Although I have personally used different strategies along these lines at different periods, one method for managing time has worked well for me for over twenty-years. I make up a calendarlike page, make copies of it, then add in the days of a current month. With this, I keep a true tally of my time spent at art or art-related efforts, first by day, then by week, and finally by month.

This gives me an honest and unvarnished look at how much time I am really putting into art. Eventually, I can see patterns of work across seasons, an entire year, and even across years. I know by now which months tend to be most active and fruitful for me, and which are usually characterized by time that is fractured and less productive. It is a system that brings clarity and reality to how I am using my time.

But it also contains another feature for me. By keeping close track of art time I begin to compete with myself. When I see that I have productively used only twelve hours in a whole week, I want to improve on this the following week. And should I see that last summer was a big loss for art time, I will want to improve on it this summer.

Each of us can bring his or her own ideas for structure into the time used for art. But structure of some kind, I believe there must be. Keeping business records for costs of materials, having a business card, keeping files of competition notices, mailing lists, and so on—all will contribute to making your art life have a real shape and priority.

Handling Rejection, Self-Doubt, and Fallow Periods

Rejection is a downside that everyone in art must suffer. Not just once or twice, but over and over again, with no letup even after years of hard work and success. Being passed over, one way or another, is a part of each artist's life that outsiders seldom know much about. To survive emotionally, to keep self-doubt and self-doubt's dark twin—bitterness—within tolerable limits, we need some survival strategies.

There has probably been no subject of the artist's condition more written about than rejection. Much good and thoughtful advice about dealing with it can be found in books, articles, and lectures. What has helped many artists is making a conscious effort toward learning to be comfortable with discomfort. This is considered a part of professionalism. It also helps to keep several irons in the fire, so everything of emotional importance is never dependent on just one thing.

A legacy of repeated rejection can be deep self-doubt. Working in isolation, as most artists do, with a minimum of feedback, encouragement, deadlines, or tangible incentives, it is difficult not to put too much weight on the negative decision of a jurist or art director. It helps at these times to hang on to being inner rather than outer directed, and to persevere more than ever with our own artistic concerns and our own themes.

Fallow periods can also bring on self-doubt. These are periods of time when we can't seem to get to our workspace, feel we have no ideas anymore, and wonder if our life in art is finished. Such periods are normal, can be of long or short duration, and can strike at any point in a career. For all the grave misgivings that accompany them, they are almost never the threat they seem. They are in fact periods of recharging our batteries, or restoring our motives and energies, and can often lead to a fresh new direction.

Exhibiting and Selling Your Art

What is often called the "art world" is not a single thing, but is actually many separate spheres of activity. In other fields, the channels of commerce are traditional and well understood. In the field of fine art, however, this is not the case. The commercial channels are many, and diverse. Some coexist with one another, some do not. Many in fact are barely, if at all, aware of others' existence. As you begin to scout galleries and other places where artwork is exhibited and sold, you will need some basic guidelines to ward off confusion.

THE CHANNELS OF COMMERCE FOR ART

Here are the major commercial outlets for fine art. They are listed in an order that makes for easy discussion, and with no value judgments intended.

Gift shops. These range from low end to high end. Some carry prints and greeting cards, and a few carry small originals. Usually commissioned sales representatives act as middlemen between retail store and artist, but not always. Retail prices are typically low, and the store expects to pay you only half the retail price. Commission for sales reps (paid by the artist) is typically fifteen to twenty percent of wholesale price.

Festivals and fairs. These are generally open-air or exposition hall venues in which artists and craftspeople show their own work in booths or on tables. Almost always, art shown has retail prices at the low end. A combination of flat fee and percentage of sales is usually charged by promoter or sponsoring group.

Artists' studios. Some artists opt for trying to sell from their studios rather than exhibiting and selling through galleries. But there are serious drawbacks here. One is that all selling costs are borne by the artist, and can be quite burdensome. To ease this, some artists have located studios fairly close to one another to promote as a group their "open studios" as regularly scheduled events.

A larger drawback is a lack of credibility, which tends to keep prices low. For if an artist has no publicly established market price for his or her work, how can a potential buyer have confidence in what might seem a high price? The artist is then put in the position of having to personally justify the work's value. This of course is what galleries earn their commissions by doing, it being more credible for a second party to sing an artist's praises.

Suburban galleries. These are very dynamic channels of commerce. There are many such galleries, servicing a wide range of socio-economic markets. Work is exhibited on a consignment basis, with the gallery taking a commission on sales of usually between forty percent and fifty percent. A professional gallery will generally have a printed contract or consignment agreement. And you can usually expect the gallery to pay all costs of exhibiting, promoting, selling, and shipping your work.

University galleries and museums. Although these do not tend to shine out as channels of commerce, sales do happen here. Commissions vary widely, and so do responsibilities of who pays for what exhibition costs. They are listed here mainly as a reminder that, with common sense, they are approachable, especially colleges and universities.

Major city galleries. These tend to be in Los Angeles, Chicago, and New York, although there are also some important and prestigious galleries elsewhere. Commissions often *begin* at fifty percent, and are frequently a good deal higher.

In most commercial activities or jobs it is possible, with effort and perseverance, to work your way up from a relatively low entrance level to a high level of responsibility, achievement, and reward. This is not quite the way it happens in art. For art's varied channels of commerce exist in different and often quite separate socio-economic cultures. Separate tracks lead to different art worlds. And because they are railroad-like tracks, you are not likely to arrive at a national or international gallery by catching your train at a local gift shop. This is not stated as a pejorative, but merely as a reality.

Even at the earliest stages of art, however, you probably already sense where your own personality and sensibility are most comfortable. And whichever track you choose, the important thing is that the sooner you get a handle on what it is you do, and in which of the many art worlds you feel most at home, the more smoothly your life in art will proceed.

Cooperative galleries. These are formed to share expenses of promoting and operating an exhibition space. The best of them have a strong commitment to the group's reputation, and jury in new members who share its philosophies. Expect to pay a commission on sold work, and also to help man the gallery, or perform other duties. Generally, an ongoing monthly or yearly association fee is also charged.

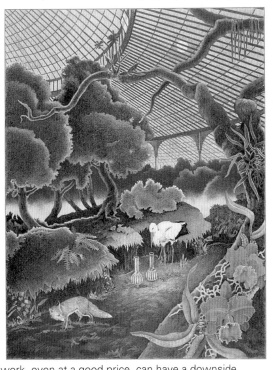

**THE FABLE OF THE FOX AND
THE STORK (FOUR PANELS)**
Colored pencil on Rising
Museum Board panels,
26 × 20" (66 × 51 cm) each.
Private collection.

A quick sale of artwork, even at a good price, can have a downside. These pieces were never exhibited. They sold as an unmatted and unframed portfolio suite to one of my gallery's regular clients. Pleasant as such a swift transaction can be, it also means that your work—the best advertisement an artist ever has—will no longer be out in the marketplace promoting you.

Alternative exhibition spaces/opportunities.
Some such spaces are libraries, government offices, community centers, bookstores, restaurants, bank lobbies, jewelry retailers, and so on. Occasional showing of artwork in this way might be appropriate. This too is a common sense call. With sales, the commission involved is often very small, and sometimes none at all.

Competitions. The best of these are juried, and the exposure for an artist may be worthwhile. Entry fees should be very low. Be suspicious of competitions with high entry fees.

One value of entering competitions is when you are seeking structure and deadlines. But avoid repeatedly choosing competitions not suitable for your work, as this will only generate a lot of unnecessary rejections. The ability to be juried in or even to win in competitions is based pretty much on knowledgeability about them and their individual biases.

Be realistic in your choice of competitions, but don't undervalue your own worth either. The ability to pinpoint your natural arena is a skill you must acquire. Many fine artists have run themselves ragged entering too many low-level competitions—and realized finally that they are doing an awful lot of work for exposure that is often pretty meaningless.

Publishing. All manner of fine art is published as what are called paper goods. Compensation to artists is through flat fees or royalties, and is usually outlined in a written contract. Publishers are not difficult to approach, and are in fact sometimes eager to hear from you, for you may be their next big seller. The steps involved in finding a publisher for your kind of work are similar to those for finding a gallery (see below). An art rep or agent is usually not necessary.

I would encourage you to put off self-publishing until you gain sophistication about the print and notecard market. Because it is a simple and fairly affordable process to have art printed, it may seem an attractive business. But it is much, much more difficult to sell the goods than to print them. If you still wish to dive into this field, first talk to others who have tried it.

WHAT YOU CAN DO NOW TO FIND A GALLERY
Even though you may feel unready for gallery representation now, here are some things you can do as preparation for it:.

Visit galleries—in and around your state and perhaps a few in nearby states. Ask to be put on their mailing lists so you can see what kinds of work they

exhibit. It may surprise you to know that gallery owners and directors often view the gallery as an art piece itself. They too have themes, and a look that speaks to them, their audiences, and their market.

Study gallery display ads in national magazines such as *Art in America, Art News,* and *Southwest Art,* to name a few. There are also architecture, interior decorating, and art collecting magazines that carry gallery ads.

Become familiar, meanwhile, with art commissions and art centers in your region. Again, ask to be added to mailing lists so you can keep abreast of this area's current issues, as well as of educational and exhibition opportunities.

DOCUMENTING YOUR WORK
As you become ready to seek gallery representation, you will need to document your best work. Photographic documentation for artists, for the past several decades, has meant 35 mm color slides, sometimes 4 × 5" color transparencies, 8 × 10" black-and-white prints, and for some venues, color copies. One or more of these will form the basis of your presentation package, help keep track of your images, and is often necessary for printed reproduction of your work.

Whatever you use, it must be of professional quality, for that is the norm, and you will not be taken seriously if you don't have it. It can be expensive or much less so if you do it yourself.

Here is an acceptable 35 mm slide. It is well-lit and well-exposed, appropriately sized with clean margins all around, and squarely positioned in its mount. The label should include (minimally) the following: title, medium, size, and artist's name. Indicate which way is up in one of these three conventional ways: (1) put a red dot at the lower left, (2) insert an arrow pointing up, or (3) write the word "top" appropriately. Information can be neatly printed in ink or computer-printed on labels. (Hint: Leave plenty of white space around drawings so they can be photographed with uncluttered edges.)

SEEKING GALLERY REPRESENTATION

To be ready for gallery representation you'll need a cohesive body of work. This means a group of images—maybe ten to twenty—that is homogeneous and executed in a single medium. Gallery directors like seeing work that appears mature, not experimental, and that has a strong, stand-out style. The best work will also have resonance, and can be appreciated on multiple levels. If your present body of work consists of mixed themes and a wide variety of subject matter, you'll need to narrow your focus. Specialization does not limit you to certain images for the rest of your life—it merely gives others some kind of handle on what it is you do now. When the time feels right, and you have a short list of possible galleries, I would recommend the following approach:

Phone the director, owner, or manager of each gallery, and ask if they are reviewing new work. If they indicate that they are, ask what materials they would like to see, and following what procedure. You need to learn from them exactly what they want to see and when. Some galleries look at new work only at a certain time each month, or only in a particular month or season. With others it may be anytime, or by verbal appointment, or through the mail. Some want to see only slides, others want to see a portfolio, or framed originals—or a combination of these. Most will also want a résumé.

Consider this: High-profile galleries receive a lot of inquiries from artists—sometimes as many as a hundred a month. So it makes good sense to be as sensitive to a gallery's needs as you can possibly be. If there is a way for you to connect personally, as a real person rather than just another anonymous inquiry, you will be ahead of the game. But it must be appropriate. Common sense, courtesy, and professionalism must always prevail. When artists tell me how easy or how hard it was to get into their galleries of choice, it has always seemed to me that it could have been predicted by looking at their work. Excellent work, well presented, is not easily passed over.

PRICING YOUR WORK

Gallery directors, seeing your work for the first time, will ask your price range. You will be better prepared for this inevitable question if you have studied pricing structure in this and other galleries. You may feel that your prices should equal that of work similar in spirit, content, medium, and size. But you must also take into account differences in reputation, market following, and perhaps exhibition history. If an artist is selling at a $1,000 to $2,000 range with work you believe comparable to yours,

you still must price yourself lower if you are unknown while he or she is well known and well thought of in this region. Be confident as you talk with the director, but leave room for the director's more experienced comments.

Here are some general "don'ts" about pricing:

1. Don't price art according to time spent doing it. Hourly rates may work for factories and some service occupations. In fine art, however, consider the artist who after a lifetime of practice can render in minutes what a beginner might spend days or weeks on. Should the seasoned artist's work, therefore, be priced considerably lower than that of a novice?

2. Don't try pricing your art by the square inch, or some other such formula related to its physical size. This is the language of mass production. It does not pertain to the creation of art.

3. Don't expect in the beginning to pass on all costs related to framing or other expenses. A framing job can cost more than some artwork itself at the beginning of a career. Until you have such costs under control, you may have to delay going public.

4. Don't set lower prices for inferior work, or don't even put such pieces out on view. A poorly done "doggie" may be all that some viewers will ever see of your work—and may seem to define your total ability. Conversely, a piece that is miles ahead of anything else you've done should probably be held back until you have more pieces like it. Your public body of work, and your prices, must have consistency.

5. Don't set different prices in different galleries because of variations in gallery commissions or markets. The artist who tries this is often unhappily surprised to learn how small a world we live in. Art buyers are not pleased to discover that they paid more for your work than they might have paid elsewhere. Nor will the higher priced gallery enjoy hearing about this.

Many successful artists price themselves modestly when starting out, expecting a long career ahead in which to regain current losses. As your art improves, so will your prices. And the broadly based group of collectors who have been purchasing your work will like seeing your value go up, and will perhaps themselves now be able to buy at higher prices. What is wanted ultimately is a price range that adequately rewards an artist for effort and skill, yet allows that artist's work to continue briskly in its natural marketplace.

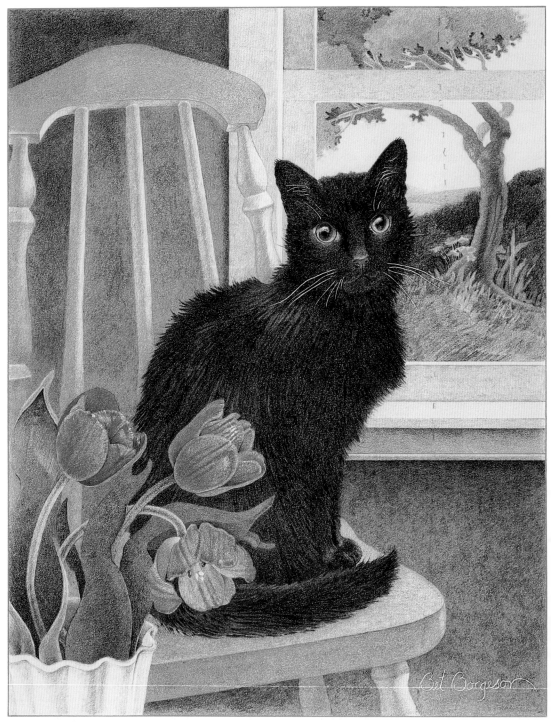

CAT AND TULIPS NO. 3
Colored pencil on Rising Museum Board,
18 × 14" (46 × 36 cm). Private collection.

The Long View: Laddering Your Goals

In all likelihood, if you strive with diligence and wit to secure gallery or publishing representation for your artwork you will achieve this. You will begin to gain the rewards of your discipline and efforts at learning your skills. But if you are to spend a lifetime in art, it is wise to know from the beginning that you will likely experience zenith periods. These are periods of intense reward for an artist from the marketplace and from peers that last about ten years, then begin to wane. Peaks, by their nature, cannot be sustained. Yet our productive lives are much longer than this.

Much of the grief, the feelings of failure and bitterness, that accompany an art lifetime's waning periods can be avoided by a laddering of goals. What is meant by this is that while in the midst of attaining and enjoying a particular art goal, we stay aware of other art-related avenues that are near us. In private and subtle ways we start at beginnings to prepare for endings. At appropriate times, we can then shift our emphasis. What we must remember, if it is a lifetime in art we want, is that the fields of art are often interrelated. They are not necessarily youth-oriented, as many fields are, and the unifying force of a fullfilling life in art is remaining in art.

To further illustrate this principle of laddering goals, consider this pair of hypothetical cases:

Say a youngish artist wants to sell her artwork and become well known in her region. She throws herself into her artwork part-time for about four years while sustaining her livelihood working as a computer programmer. She eventually secures three galleries across two states, and over the next few years begins building a reputation for steady production and a nice sales record. She leaves her "day job" and for several more years is at the top of her form, enjoying the life she had hoped to achieve. Then, for reasons that no one really knows, her intense popularity begins to subside. She loses two of her galleries, and is having a tough time keeping things going financially.

One day, almost out of the blue, a sympathetic relative offers her a chance to join a new software company. She takes the full-time job and quits art, feeling that since her artwork no longer seems to sell like it used to she has probably lost her abilities. When her husband asks her to do a piece for their new house, she doesn't feel she can do it. She tells herself she is not bitter or anything. Not really. She is forty-six, and out of art for good.

In a second hypothetical scenerio, a not quite so youngish woman has always felt she was an artist, and wishes she could be in art for the rest of her life. She enjoys studying art, improving her skills and judgment, and works part time as a substitute elementary school teacher. After about four years of fairly disciplined work at art, she has secured representation by three galleries in her region. She spends another four years developing and expressing her themes, and during this period has also started getting involved in some volunteer activities about children in art. More years go by— years of solid accomplishment and success—then her sales and status too begin to wane.

But rather than try to recapture her past success, she starts developing her volunteer work with children into full entrepreneurship. She begins conducting private art camps for children that become moderately successful. While continuing with her own artwork, she becomes interested in soliciting universities for exhibitions of art done by rural youth that she curates. In her early fifties she is finding new themes for her artwork, is showing her own work again, this time in a single prestigious gallery. Without giving the word itself much thought, she has been laddering her goals.

The important idea behind laddering is that when you keep the all-or-nothing pressure off, you can develop a more sustainable perspective. You may discover that whether or not you are juried into a show, a competition, or a gallery will be merely one of a long string of art experiences— some good, some bad. You will know too that wresting a livelihood may be a reality, but that it does not always have to be product-oriented.

Index

Appraising work, 56–59
Art as career, 117–127

Background(s)
 integrating subject
 and, 64
 pre-planning, 54–55
Burnisher(s), 12, 49–51,
 77

Color
 advancing/receding,
 31, 90
 analogous, 24–25
 basics, 21–25
 charts, 91
 complementary pairs,
 21, 25
 contrast, 26, 34–35
 and drawing, 20–21
 effective, 26–27
 found in nature, 25
 hue, 21, 24–25
 increasing sensitivity
 to, 27
 intensity, 22, 24–25,
 31–32
 juxtaposing, 23, 47–48,
 90
 layering. *See* Layering
 lifting, 49–51, 75–77
 lightfastness, 10
 local, 27
 masses, 20
 modeling, 26, 31–32
 and mood, 26, 110,
 113
 palette, 10, 84
 suggesting space, 27, 90
 temperature, 22, 31–33
 value. *See* Value
Colored pencil(s)
 brands, 10
 idiosyncracies, 21–23
 smudging, 98
 time-intensiveness, 46,
 48
 transparency, 10, 13
 water-soluble, 10
Composition, 34–37
 basic considerations, 34
 center of interest, 34,
 82, 88–89
 dynamic point, 34–35

emphases in, 22, 93,
 108
 using imagination, 108
 improving sense of, 36
 macro-editing, 92
 micro-editing, 92, 94,
 105
 pre-planning, 54–55,
 74
 still life, 62, 72
 unity, 36, 56–57, 64
Content
 ideas, 42–43, 62,
 88–89, 108
 mood/emotion, 26, 42,
 56
 and process, 54–55
Contrast, 22, 26, 34, 61
Critical judgment, 56–59

Drama, 59, 86–87, 108
Drawing, 18–20
 avoiding formulas, 111
 colorist approach to, 26
 form, volume, space,
 29–33
 freehand, 19, 45
 lay-out, 55, 66
 negatively, 49, 105
 and visualization, 19
Demonstrations
 color-lifting, 49–51
 fantasy landscape,
 110–15
 floral still life, 74–79
 impressed line, 52–53
 naturalistic landscape,
 97–107
 still life, 65–71

Edges, 38, 78
 of clouds, 103
 easing, 70
Editing, 37, 92, 94, 105
Erasers, 12, 78
Exhibiting/selling, 122–25

Finishing a drawing, 55,
 58–59
Fixative, 13, 114
Form, 29–33
 classical modeling, 18,
 29–31
Frisket film, 12, 49–51

Gallery representation,
 124–25
Graphite pencil(s), 12
 and color, 99–100
 for guidelines, 54–55,
 74

Idea(s)/inspiration, 42–43
 for landscape, 88, 108
 for still life, 62
Impressed line, 52–53

Landscape, 81–115
 center of interest,
 88–89
 clouds, 98–99, 102–03
 imaginary, 108–115
 minimalistic, 82, 92,
 94–96, 109–110,
 112
 naturalistic, 96–107
 rooms of, 82, 89
Layering
 basic tonal, 23, 46–48
 excessive, 48, 54
 heavy pressure, 46
Lifting color, 49–51,
 75–77
Light table, 14–15, 55, 66

Materials/tools, 8–15
Modeling form, 29–33
 problem with
 photography, 45

Negative space. *See*
 Background

Palette, 10, 84
Paper/surfaces, 11
Pencil(s), 10
 extenders, 13
 pressure, 41, 46
 sharpeners, 12, 86
 sharpness, 12, 55
 and texture, 47, 99, 105
 and value, 68, 71, 78,
 114
Personal style, 18, 42–43
Perspective, 19, 102–03
Photography
 distortions in, 44–45
 field equipment, 86
 influence of, 36, 44

as reference, 29, 36,
 44–45, 86, 92, 97,
 108, 110
Pricing art, 125

Rejection, 121
Ruskin, John, 34

Slide example, 124
Space, 29
 division of, 34–35, 93
 suggested by color, 26, 90
Still life(s), 61–79
 arranging, 62, 65, 72
 expanded, 61–62
 floral, 72–79
 lighting, 63, 77

Technique(s)
 basic, 46–54
 color lifting, 49–51,
 75–77
 impressed line, 52–53
Texture, 46–47
 control/refining, 12,
 41, 47, 71, 78,
 98–99, 105, 114
 influenced by paper, 11
Tips, 12, 28, 43, 55, 78,
 86, 97, 99
Tracing as drawing aid,
 19, 45
Transferring, 55, 66

Unity, 36, 56–57, 64

Value
 adjusting, 68, 105, 114
 changes in modeling,
 29–32
 and clouds, 102–103
 contrast, 22, 26, 34
 darkener, universal, 28
 darkening, 28, 114
 inherent in pencil, 22
 and mood, 26
Viewfinder, 19
Viewpoint, 62, 65

Wax bloom, 13, 114
Working outdoors, 84, 86
Working process, 54–55,
 58, 74
Workspace, 14–15